ANDY WARHOL
SOCIAL OBSERVER

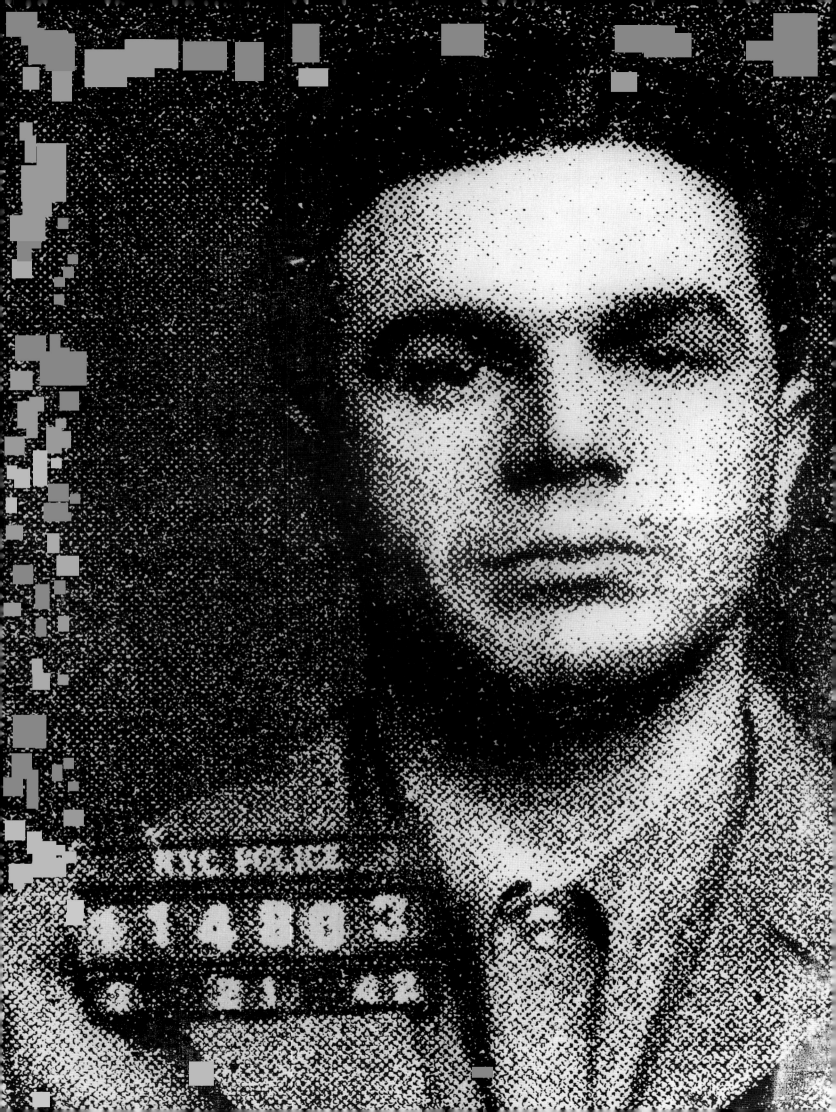

ANDY WARHOL SOCIAL OBSERVER

Jonathan P. Binstock

with essays by
Maurice Berger
Trevor Fairbrother

Pennsylvania Academy *of the* Fine Arts
MUSEUM ᛫ SCHOOL

Published on the occasion of the exhibition

ANDY **WARHOL** SOCIAL **OBSERVER**

Organized by the Pennsylvania Academy of the Fine Arts

Pennsylvania Academy of the Fine Arts, Philadelphia
June 17–September 21, 2000

Corcoran Gallery of Art, Washington, D.C.
December 22, 2000–March 12, 2001

Curator: Jonathan P. Binstock
Editor: Janet Wilson
Design: John Holloman for Curious Industries
Printing: Piccari Press

Front Cover: **SELF-PORTRAIT** (detail), 1964. Synthetic polymer paint and silkscreen ink on on canvas, 20 x 16" (50.8 x 40.6 cm). Courtesy The Brant Foundation, Greenwich, Conn.

Frontispiece: **MOST WANTED MEN NO. 1, JOHN M.** (detail), 1964. Synthetic polymer paint and silkscreen ink on canvas, 49 x 37 3/4" (124.5 x 95.9 cm). The Herbert F. Johnson Museum of Art, Cornell University. Purchase Funds from the National Endowment for the Arts and individual donors

 Mellon

The exhibition is supported by a grant from the Mellon Financial Corporation Foundation, with additional funding from the Women's Committee of the Pennsylvania Academy of the Fine Arts

Binstock, Jonathan P., 1966-
 Andy Warhol : social observer / Jonathan P. Binstock.
 p. cm.
Published on the occasion of an exhibition organized by the Pennsylvania Academy of the Fine Arts, Philadelphia, Pa., June 17 through September 21, 2000.
Includes bibliographical references.
 ISBN 0-943836-20-4
1. Warhol, Andy, 1928---Exhibitions. 2. Art and society--United States--Exhibitions. I. Warhol, Andy, 1928- II. Title.
 N6537.W28 A4 2000

00-009287

Contents

Foreword

This exhibition and the accompanying catalogue view the work of Andy Warhol in its "social" aspect. This aspect is fundamental to the artist's identity, for he was—without peer among fellow artists—a *social* phenomenon, never far removed from the media's attention and adroitly able to manipulate his celebrity in ways that overlapped the nature of his work. We propose to examine this overlap by looking at the subjects and themes that preoccupied Warhol throughout his career. Implicit in this exercise is the place of Warhol's creative achievement in the history of American art. As much as his work brilliantly plays out the currents of late modernism, it also shares striking affinities with a documentary tradition that has particularly deep roots in twentieth-century American art. Although the dispassion of Warhol's work and its frequent focus on celebrity are inimical to the overt political agenda of Social Realism, it is hard to conceive of Warhol independent of this tradition, for so much of his work seems tied to the social fabric that he helped to define, and chronicled obsessively.

The works in this exhibition represent themes that were of interest to Warhol throughout his career, emphasizing continuities manifested in his work from as early as the late 1940s until the time of his death in 1987. Warhol's interests were not static, though their character and origins are inextricably linked to the decade of the 1960s and his emergence as one of its most important players. No artist more fully embodied the dynamics of the 1960s than Warhol. His passage from designer to artist to Pop superstar unfolded seamlessly in that decade, expanding in its course the potential roles of the artist as a social phenomenon. He was never "just" an artist. With seeming instantaneity he became, and always remained, a celebrity. He was the product and manipulator of the media's attention, strategically placed at the epicenter of the hip, fast-moving social milieu of New York's club scene. His enterprise, moreover, was never limited to a static or traditional norm of the fine arts. The studio that Warhol established in the early part of the decade quickly became known as the Factory, which bears associations with labor and capital that are relevant to a new mythology of the artist that Warhol would come to embody. He was a prolific filmmaker, writer, and producer, who briefly ran a discotheque featuring the alternative rock music of the Velvet Underground, with whom he was creatively involved. In 1969 he launched the magazine *Interview* (which is still being published), for which he established Warhol Enterprises, Inc., becoming perhaps the first "corporate" artist. "I started as a commercial artist," he said, "and I want to finish as a business artist. After I did the thing called 'Art' or whatever it's called, I went into business art...the most fascinating kind of art" (quoted in *THE Philosophy of Andy Warhol*, 1975). Rather than undermining his artistic "legitimacy," Warhol's unabashed commercialism reinforced the purview of his art, establishing his credentials as the preeminent artist of late capitalism.

Warhol's earliest paintings, derived from comics and consumer culture, quickly evolved to expose the underbelly of violence that was never far removed from the fevered pitch of the "go-go" 1960s. Paintings of disasters—car crashes and suicides—were created alongside the commodity depictions—Campbell's Soup cans, Coca-Cola bottles, S & H Green Stamps—and the earliest celebrity images—Troy Donahue, Elvis Presley, Natalie Wood—reflecting the ubiquity of the media image and its bloodless depersonalization. The iconic images of Marilyn Monroe (1962) almost immediately followed her suicide. Then came the paintings of Jacqueline Kennedy in mourning (1963–64), of "Race Riots" (1963–64), "Electric Chairs" (1963–67), the "Thirteen Most Wanted Men" (improbably installed on the facade of the New York Pavilion at the 1964 World's Fair). In these works Warhol developed his syntax of multiple images and the semantics of the screenprint, reinforcing the commodity status of his subjects. The emphatic two-dimensional sheen of these paintings and prints established a strange dissonance between the implied pathos of the subjects and the inscrutability of his overtly mechanical surfaces, noteworthy for the seeming absence of the artist's hand.

Intentionality—the question of Warhol's creative strategies and relevance—has always been at the core of his artistic interest. As Jonathan Binstock, the curator of this exhibition, observes in the catalogue's first essay, Warhol cultivated a strategy of coy disengagement from the interpretation of his work. He spoke his mind on a great variety of subjects, operating in close proximity to tape recorder and camera, becoming, in Hal Foster's trenchant phrase, "the great *idiot savant* of our time" ("Death in America," in *Who is Andy Warhol?* 1997). Warhol's voluminous commentaries, recorded in a variety of texts, encourage the reading of his work as all surface: "I see everything [as] the surface of things, a kind of mental Braille, I just pass my hands over the surface of things," he commented. He espoused a preference for "boring" things (in contradiction to many of his subjects), aspired to create like a "machine," and left it to his public to draw its own conclusions about the accuracy of such descriptions, their implications and legitimacy.

The serious viewer of Warhol's work nevertheless understands that his attraction to the "surface of things" is not to be confused with the superficiality of the work itself and its artistic merits. Whatever one may make of Warhol's abundant and sometimes contradictory pronouncements, it is understood—intellectually, and often intuitively—that his work embodies the culture of late-twentieth-century America like no other. Surely this accounts for his singular popularity and influence today. By looking, as it were, at his "field of vision," we hope to encourage a deeper understanding of Warhol's artistic relevance, his antecedents, and his place in the history of twentieth-century American art.

DANIEL ROSENFELD

The Edna S. Tuttleman Director
Museum of the Pennsylvania Academy of the Fine Arts

RIGHT: **DAILY NEWS** (detail), ca. 1967. Screenprint on paper, 49 7/8 x 29 7/8" (126.7 x 75.9 cm). Courtesy Gagosian Gallery, New York

Acknowledgments

Andy Warhol: Social Observer was conceived to accompany the exhibition *Robert Gwathmey: Master Painter*, organized by the Butler Institute of American Art, Youngstown, Ohio, and on view at the Pennsylvania Academy of the Fine Arts from June 17 through August 13, 2000. Gwathmey, among the most original of the Social Realist painters in this country, studied at the Academy from 1926 to 1930. The inspiration for a concurrent exhibition of the work of Andy Warhol is therefore historical and perhaps revisionist, aspiring to reevaluate this artist in the context of developments that have most often been considered apart from the history of modernism. We hope that the joint presentation of these exhibitions at the Academy will contribute to a deeper understanding of the true complexity of American art in the twentieth century, to which this institution is so deeply committed.

We are especially grateful to the Mellon Financial Corporation Foundation for its sponsorship of this project. We also extend our thanks to the Women's Committee of the Pennsylvania Academy of the Fine Arts for its generous support. We wish to express our appreciation to The Andy Warhol Museum, Pittsburgh, and The Andy Warhol Foundation for the Visual Arts, Inc., New York. Their generous spirit and commitment to the reputation of Warhol have been indispensable to the realization of this exhibition. From The Andy Warhol Museum, we would especially like to thank Tom Sokolowski, Director; John Smith, Archivist; Matt Wrbican, Assistant Archivist; Margery King, Associate Curator; Geralyn Huxley, Associate Curator, Film and Video; Greg Pierce, Technical Assistant, Film and Video; and Lisa Miriello, Curatorial Assistant. We are also very grateful to Claudia Defendi, Chief Curator of The Andy Warhol Foundation for the Visual Arts, for her ongoing assistance in helping us locate works for this exhibition.

The generosity of the numerous lenders to the exhibition, both public and private, has been instrumental to our efforts. For their assistance in researching works and securing loans, we would especially like to thank Jean Bickley, The Brant Foundation, Greenwich, Conn.; Laura Bloom, Registrar, Sonnabend Gallery, New York; Rose Dergan, New York; Molly Donovan and Carlotta Owens, Assistant Curators, National Gallery of Art, Washington, D.C.; Vincent Fremont, Vincent Fremont Enterprises, New York; Madeleine Grynsztejn, Curator of Contemporary Arts, Carnegie Museum of Art, Pittsburgh; Scott Habes, Director, The Art Gallery, University of Maryland, College Park; Jan Howard, Associate Curator, Baltimore Museum of Art; Karl Hutter and Jessie Washburne-Harris, Gagosian Gallery, New York; Marilyn Kushner, Curator of Prints, Drawings and Photographs, Brooklyn Museum of Art; Alberto Mugrabi, New York; Mark Nochella, Ronald Feldman Fine Arts, New York; Betsy Rosasco, Associate Curator of Later Western Art, The Art Museum, Princeton University; Cora Rosevear, Associate Curator, The Museum of Modern Art, New York; Barbara Tannenbaum, Chief Curator, Akron Art Museum; Sean Ulmer, Curator of Painting and Sculpture, Herbert F. Johnson Museum of Art, Cornell University, Ithaca, New York; Michael Taylor, Assistant Curator, Gilbert Vicario, Curatorial Assistant, and Madeline Viljoen, Intern, Philadelphia Museum of Art; and Anne Prentice Wagner, Curatorial Assistant, National Portrait Gallery, Washington, D.C.

We would also like to thank Trevor Fairbrother, Deputy Director and Jon and Mary Shirley Curator of Modern Art, Seattle Art Museum; and Maurice Berger, Senior Fellow, Vera List Center for Art and Politics, New School for Social Research, New York, for their willingness to participate in this project and for the insights they have brought to their essays for this catalogue.

Janet Wilson has edited the essays, and John Holloman of Curious Industries has designed this handsome catalogue. We also wish to acknowledge the contributions and support of our many colleagues at the Pennsylvania Academy of the Fine Arts, especially Joshua C. Thompson, President and CEO; Derek Gillman, Executive Director and Provost; Penny Blom, Director, Marketing and Communications; Keith Crippen, Exhibition Design; Mary Anne Dutt Justice, Director, Development; Barbara Katus, Rights and Reproductions; Lorena Sehgal, Associate Registrar; and Ka Kee Yan, Registrar's Assistant.

DANIEL ROSENFELD
The Edna S. Tuttleman Director
Museum of the Pennsylvania Academy of the Fine Arts

JONATHAN P. BINSTOCK
Assistant Curator

Lenders to the Exhibition

Akron Art Museum

The Andy Warhol Foundation for the Visual Arts, Inc., New York

The Andy Warhol Museum, Pittsburgh

The Art Gallery, University of Maryland, College Park

The Art Museum, Princeton University

The Brant Foundation, Greenwich, Conn.

Brooklyn Museum of Art

Carnegie Museum of Art, Pittsburgh

Leo Castelli Gallery

Ronald Feldman Fine Arts, New York

Gagosian Gallery, New York

The Herbert F. Johnson Museum of Art, Cornell University

Jane Holzer, New York

Christopher Makos, New York

Museum of Art, Rhode Island School of Design, Providence

The Museum of Modern Art, New York

National Gallery of Art, Washington, D.C.

National Portrait Gallery, Smithsonian Institution, Washington, D.C.

O'Hara Gallery, New York

Philadelphia Museum of Art

David and Gerry Pincus, Philadelphia

Private Collection

Sonnabend Collection

Laura McIlhenny Wintersteen

essays

Andy Warhol: Social Observer

JONATHAN P. BINSTOCK
Assistant Curator, Pennsylvania Academy of the Fine Arts

> Well, the reason I don't sort of get involved in [politics] is because I sort of believe in every-
> thing. One day I really believe in this, and the next day I believe in doing that. I believe in no
> war, and then I do believe in war if you have to do it. I mean, what can you do about it?
>
> —Andy Warhol [1]

In 1968, a year when political turmoil convulsed the nation—racial strife at home, the Vietnam War abroad—Andy Warhol was asked if he thought of himself as apolitical. His answer, reduced to its basic elements, goes something like this: "I don't get involved with politics. I believe in everything." By at least the 1950s, the idea that art and politics should be mutually exclusive had become broadly accepted. Artists of all types and backgrounds viewed this dissociation as necessary in a world in which politics seemed to pervade everyday life. In order for art to be transcendent, it *must* elide political concern. This was obviously not the point of Warhol's egalitarian pronouncement, *I believe in everything*, which is arguably much more radical and perhaps even utopian when compared with the "art for art's sake" position of the postwar modernists who preceded him. Or was his lack of commitment reactionary and pernicious, the sign of someone insensitive to social ills and without political concerns, one who was part of "the problem" as opposed to "the solution"? Warhol's ambiguous position vis-à-vis politics and social action makes it difficult to tell.

If Warhol was a compelling public figure—a person experienced not only through his art but also on television and in newspapers and magazines—it was because he was so elusive, so enigmatic. His dismissal of politics, linked with his all-encompassing belief system, is a good example of the kind of thinking with which he tantalized and bemused his public. Contradiction was a hallmark of his self-effacing persona. He was notoriously ambivalent about almost everything he said or did. If we think of him today as indifferent and his art as shallow, it is largely because this is the way he wanted to be understood. No artist more expertly controlled how he was interpreted by the critical and popular media than Warhol. He fashioned himself as an expressionless counterpoint to the self-consciously heroic and transcendent modernism of the Abstract Expressionists. "I don't talk much or say very much in interviews," Warhol said famously. "I'm really not saying anything now. If you want to know all about Andy Warhol just look at the surface of my paintings and films and me, and there I am. There's nothing behind it."[2] This often-cited quotation warrants further examination precisely because of its prevalence in the literature on Warhol. It is arguably the single most influential piece of information we have about the artist. Warhol happily cultivated a reputation for being obtuse, conceded that his art meant little, if anything at all, and claimed that his choice of subjects was arbitrary at best. Politics? Social concern? Given the prevailing explanation that Warhol was uncaring and superficial, nothing could have been farther from his mind or, for that matter, our understanding of his mind.

The art historian Thomas Crow memorably called Warhol's paradoxical bluff in an essay titled "Saturday Disasters: Trace and Reference in Early Warhol," which was published in 1987 on the occasion of the artist's death.[3] Examining Warhol's images of death and disaster (car crashes, electric chairs, race riots, etc.); the celebrity portraits of Marilyn Monroe, Elizabeth Taylor, and Jacqueline Kennedy; and the Campbell's Soup cans, Crow suggested that the artist's most celebrated paintings of the early 1960s are political in the broadest and fiercest sense. They are indictments of consumerism—the very nature of American popular culture—because they depict the moment when commodity exchange breaks down. The most obvious of Crow's examples is Warhol's notorious series depicting car crashes, in which the shiny new auto many of us desire is transformed into a death machine.

LEFT: **CAMOUFLAGE** (detail), 1986. Synthetic polymer paint and silkscreen ink on canvas, 80 x 80" (203.2 x 203.2 cm). Courtesy Gagosian Gallery, New York

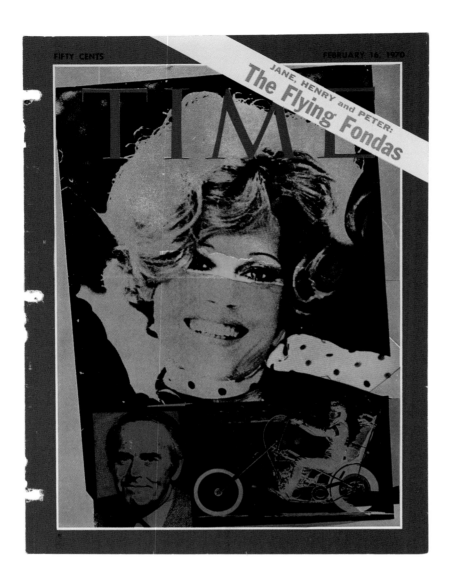

FIGURE 1: *Time* magazine cover design by Andy Warhol, 16 February 1970. The Archives of The Andy Warhol Museum, Pittsburgh. Founding Collection, Contribution The Andy Warhol Foundation for the Visual Arts, Inc.

In Crow's essay—a landmark study that turned our attention from the medium to the message of Warhol's imagery, its *subject matter*—he dismissed all of the artist's work made after 1965 on the grounds that it had lost its only critical edge: the ability to reveal the underbelly of American culture and confront the insidious truths about who we are as a society. After 1965, Crow argued, the Warhol clichés "began to ring true."[4] He was referring to Warhol's self-described banality and the opportunism that characterized his career in the 1970s and 1980s. Like most of the critics who have written persuasively on the artist, Crow maintained that, in the end, Warhol's description of himself as apathetic and superficial was his most dispassionate representation of all.

Andy Warhol: Social Observer begins where Crow and many other writers leave off, because it is precisely when the clichés begin to ring true that Warhol becomes extraordinarily complex, compelling, and intractable. As this exhibition and the accompanying catalogue seek to show, Warhol never lost his critical edge; rather, this edge shifted according to the vicissitudes of his relationship with the art world and the international social set of which he was a central figure in the 1970s and 1980s.

Warhol is most renowned for his art of the 1960s, when he developed his reproduction-based silkscreen painting techniques and challenged the distinctions between prints and paintings, high and low art, hand- and machine-made, the original and the copy. As a result, he achieved avant-garde status and gave a recognizable personality to the new Pop art. In the 1970s and 1980s, he was considered much less relevant in the sphere of progressive contemporary culture. As his work grew more diffuse and ubiquitous, he fell from critical favor. Warhol brazenly pursued portrait commissions, sold advertising space in his *Interview* magazine, and appeared in joint exhibitions with popular artists such as Jamie Wyeth (1976–77) and LeRoy Neiman (1981), who were generally dismissed by the art-world establishment.[5] These two-person exhibitions certainly did not help and probably hurt Warhol's ailing reputation among critics, curators, and collectors at the time. However, it is in these unashamedly commercial contexts—treacherous for any artist aspiring to canonical greatness on a par with Jackson Pollock or Pablo Picasso—that Warhol's critical edge becomes most salient. As he had done in the 1960s, when he borrowed images from popular culture, Warhol was flirting with a cultural milieu that the art establishment considered taboo, outside the realm of serious art.

Since the early 1980s, Warhol's reputation has traveled from the seemingly debased to the strato-spheric. In a January 2000 issue of *The New Yorker*, artist David Hockney likens Warhol's line drawings (similar in type to his depictions of Muhammad Ali and Russell Means in this exhibition [figures 36 and 52]) to the drawings of the French Neoclassicist and legendary draftsman Jean-Auguste-Dominique Ingres.[6] Indeed, some of the portraits that comprise the 1977 "Athletes" series that Warhol exhibited with Neiman look as fresh and poignant today as almost anything the artist ever made. Warhol's depictions of Ali and O. J. Simpson display not only his deft line and sensitive color handling but also his uncanny ability to put his finger on the pulse of a generation. In the case of O. J., who has become a defining figure for at least two generations, falling from sports hero to reputed murderer, Warhol's prescience seems to tran-scend his premature death in 1987 (figure 55).

Andy Warhol: Social Observer explores seven themes that cut across the artist's oeuvre, characterizing his engagement with what he perceived as socially relevant issues in art and life: Disguise, Death and Disaster, Politics, Cover Stories, Advertising, Celebrity, and Symbolism. For the purposes of organization and clarity, I have conceived of these themes as discrete categories, but they also often overlap. Consider, for example, *Sixteen Jackies* (1964), which depicts Jacqueline Kennedy at different moments during and after the fateful trip to Dallas, Texas, in 1963, when John F. Kennedy was assassinated (figure 26). This work could be appro-priately placed in any of several categories: Death and Disaster, Politics, Celebrity, or, considering the source of the imagery—photographs reproduced in a December 6, 1963, issue of *Life* magazine—even the Cover Stories section. Another multifaceted example is the late painting *Map of Eastern U.S.S.R. Missile Bases* (ca. 1985–86), part of a series commonly referred to as Warhol's "Black-and-White Advertisements," which was derived from a map reproduced in a newspaper (figure 29). A document of what was a political reality, the painting serves as an ominous portent of the mass destruction and death that the Cold War could unleash.

Death, politics, celebrity, and their mediation through television, magazines, newspapers, and film have always been construed as essential components of Warhol's art. What distinguishes this Warhol exhibition from previous ones is not so much the themes per se as the way in which they transcend chronology. By grouping early and late works together within conceptually integrated sections, this exhibi-tion explores the full range of the artist's career in an effort to elucidate how social and political phenom-ena influenced his work from beginning to end.

The exhibition consists of more than 85 paintings, prints, photographs, one film, and mate-rial borrowed from the Archives of The Andy Warhol Museum in Pittsburgh. This includes issues of *Interview* magazine and other publications for which Warhol designed covers; two book-length photo essays, *Andy Warhol's Exposures* (1979), which the artist initially wanted to title *Social Disease*, and *America* (1985; figures 14–18); facsimiles of pages from one of Warhol's scrapbooks con-taining articles that mention him; and selections from his collection of photographs, clippings, and pro-motional imagery that figure prominently in the works on dis-play.[7] One of Warhol's "Time

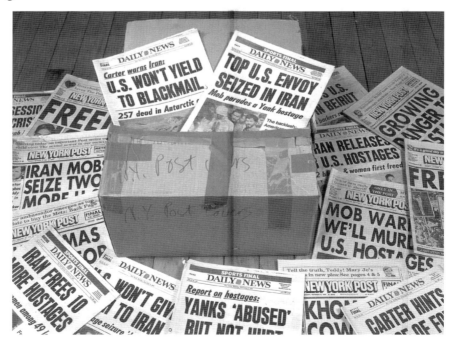

FIGURE 2: **TIME CAPSULE #232** (December 1978–February 1980), including newspapers document-ing the crisis in Iran. The Archives of The Andy Warhol Museum, Pittsburgh. Founding Collection, Contribution The Andy Warhol Foundation for the Visual Arts, Inc.

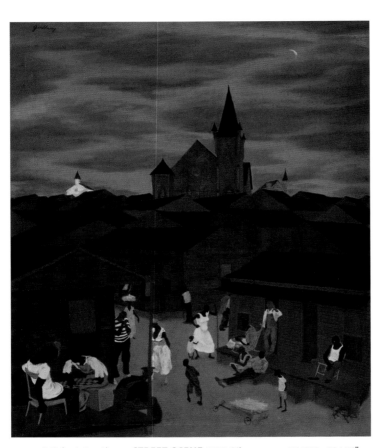

FIGURE 3: Robert Gwathmey, **STREET SCENE**, 1938. Oil on canvas, 36 3/16 x 30 1/16" (91.9 x 76.4 cm). Pennsylvania Academy of the Fine Arts, Philadelphia. Joseph E. Temple Fund

Capsules"—#232, which contains actual front pages of the *New York Post* and *New York Daily News* from the late 1970s to early 1980—is also included to provide a glimpse into a rarely examined aspect of his infatuation with the detritus of everyday life (figure 2).[8] From this wide range of artworks and related materials, Warhol emerges as a passionate social observer—even obsessive in his attraction—whose ambivalence sometimes gives way to strong opinions, affiliations, and sympathies. Rejecting the view of Warhol as uncaring and disengaged, the exhibition directs attention to a principal aspect of his overall production that has largely been dismissed or ignored, particularly in his work after the late 1960s.

The idea that Warhol was a social observer, documentarian, and sometime critic was first discussed by Rainer Crone in his 1970 monograph, in which he portrayed the artist as socially conscious, politically motivated, and heir to the tradition of American Social Realists, such as Ben Shahn and Robert Gwathmey (figure 3), whose roots lie in the unflinching urban modernism of Robert Henri, George Bellows, and the Ashcan School.[9] Of course, not all critics have agreed. Benjamin Buchloh, for example, sees Warhol's politics as indifferent from the start and views the artist's complicity with the conservatism of President Reagan's 1980s as cynical, self-serving, and, the reader is urged to conclude, reprehensible.[10] While it can be fascinating to debate whether Warhol was apolitical or political, critical or acquiescent, a Democrat or a Republican, this exhibition is, above all, concerned with whether his fixation on and exploitation of the machinations of the social world represent an implicit critique of that world. "Andy wasn't apolitical," as Warhol biographer Bob Colacello has written, "he was ruthless."[11] His vantage point vis-à-vis the dynamics of power is integral to all of his art and deeply embedded in his abiding historical significance.

Throughout his career, Warhol adroitly exploited the consumerist system that he so cleverly made the linchpin of his art.[12] His strategies for securing fame and the circumstances that bolstered his efforts continue to this day. It was his ability to capitalize on the flow of commerce that has secured his preeminence as one of the most—if not the most—significant American artists of the late twentieth century. This is confirmed not only by the strength of Warhol's legacy art-historically and in the marketplace, but also by the influential institutions he left in his wake: The Andy Warhol Museum in Pittsburgh and The Andy Warhol Foundation for the Visual Arts, Inc. No matter how cynical and disheartening this fact may be to some people, Warhol is proof positive of the superior status conferred upon commerce in a capitalist world—that even in matters of art, money is the bottom line.[13]

As compelling as Marxist-informed theoretical models may be in the field of Warhol studies, the present exhibition is designed, alternatively, to demonstrate how the artist's observations of American society suggest critiques that outstrip analyses derived mainly from theories of production and consumption. The exhibition does not, for example, privilege Warhol's reproduction-based aesthetic or condemn his opportunism. The focus is on what the artist looked at, how he looked at those subjects, and, in certain situations, how he himself was perceived by the society so inclined to keep its media trained on him. Issues of technique and process, so crucial to any deeper understanding of his work, figure in the exhibition's dis-

play and argument, but are never considered apart from those of subject matter, for Warhol never divorced his regard for depicted content from his interest in media and methods of reproduction.

The exhibition's first section, **Disguise**, represents the role of concealment in two series of self-portraits that encapsulate Warhol's career as an exhibiting (as opposed to a commercial) artist. It would be difficult to identify a silkscreen, lithograph, or painted self-portrait by Warhol that does not in some way obscure his visage, either through partial concealment—the artist shielding his face with his fingers, sunglasses, or a camouflage pattern—or through the abstraction of the picture's formal elements. Notoriously uncomfortable with his looks, Warhol manipulated his representation to obscure details of his appearance and to present, as one might expect, the best image possible: "When I did my self-portrait, I left all the pimples out because you always should. Pimples are a temporary condition and they don't have anything to do with what you really look like. Always omit the blemishes—they're not part of the good picture you want."[14] Warhol doctored his portrait commissions of the 1970s and 1980s in a similar way. "Flattery sells" was his mantra.[15] However, the image manipulations in his self-portraits are not just cosmetic in effect; they reveal his strategies of social engagement.

In the early photo-booth *Self-Portrait* (1964), Warhol is the ultimate observer, a veritable sleuth complete with sunglasses and trench coat (figure 19). The stealthy attire and closetlike setting in which the original photograph was taken lend a mysterious tension to the image, suggesting that the sitter is remote even though the circumstances of our engagement with him are intimate. The awkward cocking of the head, mouth slightly open, objectifies Warhol's discomfort before the probing lens. The painting's covert sensibilities are represented in the later *Self-Portrait* (1986) by means of a veil of camouflage (figure 21). In this monumental painting, the artist presents his disembodied head as a looming icon to be revered and perhaps even feared, fright wig and all. The gesture is fraught with conflict, however, considering that the bright red and pink camouflage pattern, originally designed not to be seen, functions as a kind of beacon, drawing attention to the portrait just as it obscures our ability to clearly see the image.

Self-Portrait (1986) is a metaphor for the public relations tactics Warhol perfected throughout his career. Extremely shy in front of the camera when he first became well known, the artist quickly developed his coy evasiveness into an effective strategy for remaining in the public eye without risking excessive exposure. Even in the 1970s and 1980s, after he had achieved celebrity status, Warhol habitually adopted a self-effacing demeanor in the presence of his equally glamorous socialite friends. By presenting himself to the media as yet another star-struck observer of the rich and famous, he created the entertaining fantasy that his viewpoint and that of his audience were similarly glamorized by the dazzling company he kept. Of course, throughout this period he was exhibiting his own uniquely amusing media personality.

Seen in this context, the nonfigurative "Camouflage" (1986) paintings are acute distillations of Warhol's self-constructed ambivalence: his wish to be seen and to remain invisible; to have a place among the

FIGURE 4: Source image for Andy Warhol's series "5 Deaths" (1963), UPI photograph, 1959. The Archives of The Andy Warhol Museum, Pittsburgh. Founding Collection, Contribution The Andy Warhol Foundation for the Visual Arts, Inc.

celebrities, all the while believing that he is an outsider, a fan, who must work his way into the inner circle (figure 20). It is the space between these alternatives—the shallowness of the distracting camouflage surface and the possibility that some kernel of truth about the artist and his social affiliations is deeply concealed within—that is the locus of Warhol's disguise. In this interstitial space—both conceptual and visual—the artist created room for maneuvering and for a new kind of multifaceted, ambivalent critical distance, regarding both images of himself and the outside world.

Of all the works exemplifying Warhol as social observer, those in the **Death and Disaster** section would seem to require the least explanation because of their "one-to-one ratio of impact," as Gerard Malanga, Warhol's studio assistant during the 1960s, has stated.[16] Adapted from newspaper, press-agency, and police photographs, they appear to be documentary in nature and, on this most cursory level, the quintessential embodiment of Warhol's famously deadpan aesthetic, which he promoted through memorable statements such as, "I want to be a machine" and "I think somebody should be able to do all my paintings for me."[17]

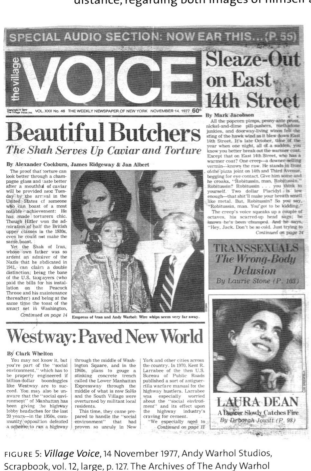

FIGURE 5: *Village Voice*, 14 November 1977, Andy Warhol Studios, Scrapbook, vol. 12, large, p. 127. The Archives of The Andy Warhol Museum, Pittsburgh. Founding Collection, Contribution The Andy Warhol Foundation for the Visual Arts, Inc.

Today, when computer-generated imagery is ubiquitous and seemingly unmediated representations of graphic violence pervade television, film, popular music, and printed media, Warhol's early silkscreen paintings have, with age, transcended their machine-made disposition and accrued a handmade finish. Despite their subjects and origins, these works are aesthetic expressions in which the morbid fascinations of the artist-observer are ominously present.

The elaborate process required to make these pictures testifies to their inherent artful intention. Warhol or his assistants began by making black-and-white photographic transparencies from original paper images, either the Benday-dot type found in newspapers (in which case the dots were magnified in the finished work) or from actual glossy photographs without the matrix pattern (figure 4). In the latter case, they sometimes decided to add the dots by means of a 100-, 200-, or 300-dot (fine grain) silkscreen. It all depended on what kind of image Warhol wanted to make. A high-contrast image such as *Race Riot* (1964), which is black and white with little intermediate gray scale, involved eliminating some of the tonal values from the original photograph (figure 25).[18] The selection of images also reflects the artist's cultivation of a certain kind of loaded expressive content. Rather than wait passively for the right images of death and disaster to cross his line of sight, he and his assistants sought out the most gruesome unpublished examples from press agencies and other resources typically reserved for journalists.[19] Unlike the original documentary sources, however, Warhol's paintings and prints were intended to horrify, and they do.

Politics as subject matter became overt in Warhol's art in 1972, when he returned from his so-called retirement from painting, which he had announced in 1965 at an exhibition of his "Flowers" at the Galerie Ileana Sonnabend in Paris. In 1972 he executed well over one thousand canvases and produced a limited edition of screenprints, all depicting the Chinese Communist leader Mao Zedong, who was at that time, according to the artist, the most famous person in the world (figure 39).[20] Warhol's *Mao* is the perfect companion to another limited-edition screenprint from that year, *Vote McGovern*, which portrays an equally garish colored bust of then-President Richard M. Nixon, who was seeking reelection on a platform

that credited him with reopening China to the West (figure 40).[21] The two series represent Warhol's conflicted involvement with the political sphere, which ranged from partisanship—the screenprint of a nauseous green Nixon on behalf of the McGovern campaign and later print editions on behalf of the Jimmy Carter and Edward Kennedy campaigns—to a shrewd ability to know not only what would work and sell but also when. On this score, *Mao* is an especially good example. The gallery exhibitions of his portraits in New York, Zurich, and Paris were great successes.[22] Warhol emerged from "retirement" with much media fanfare and in a grand style that typified his later persona.

"Politics," as Bob Colacello perceptively notes, "combines two of the themes that interested Andy most: power and fame."[23] In the 1970s Warhol avidly pursued these dual ambitions, attempting to secure lucrative portrait commissions from as many political figures as possible. He painted silkscreen portraits of Israeli Prime Minister Golda Meir (1975), West German Chancellor Willy Brandt (1976), and the Shah and Empress of Iran (ca. 1978; figures 27 and 28), to name just a few. Angling for the latter commission, Warhol dined at the Iranian ambassador's residence in New York about once a month in 1975 and 1976, as well as with other diplomats, business people, socialites, and cultural figures.[24]

Warhol's involvement with the Iranians was not without its complications. In 1977, as a leadership crisis was developing in Iran, the artist was lambasted for his social connections with the country's top government officials. "Beautiful Butchers: The Shah Serves Up Caviar and Torture" was the newspaper headline for an article in New York's *Village Voice* that skewered Warhol, among others, in a diatribe against the Shah's autocratic regime and those who would willfully be associated with it (figure 5).[25] Warhol's greatest fear in appearing politically affiliated was not the bad press, but the possibility that he might offend someone who would then cancel a subscription to his *Interview* magazine, or, worse yet, cancel an advertisement.[26]

Warhol's campaign donations indicate Democratic leanings, but he never once voted, according to Colacello's recollection, and he was just as inclined to conceal his affiliations, as the following exchange with a Mexican interviewer makes clear:

Reporter: Who do you favor for president?
Warhol: Nixon's just great.
Reporter: Why?
Warhol: He travels so much—like a movie star, a Superstar.
Reporter: Why is this?
Warhol: I guess he likes to be on TV. He's good friends with Bob Hope, Ronald Reagan, Bing Crosby, Frank Sinatra and Shirley Temple.[27]

Notwithstanding the banter with which Warhol regularly entertained the media, his politics were arguably most ambiguous when he sought political portraits without regard for the beliefs and policies of his potential sitters. He unashamedly and obsessively pursued a portrait commission (which he never obtained) from Imelda Marcos, the wife of Ferdinand Marcos, president of the Philippines from 1965 to 1986, whose authoritarian regime was harshly criticized for corruption and suppression of democratic processes. Warhol's motivations were financial rather than political. As Colacello writes,

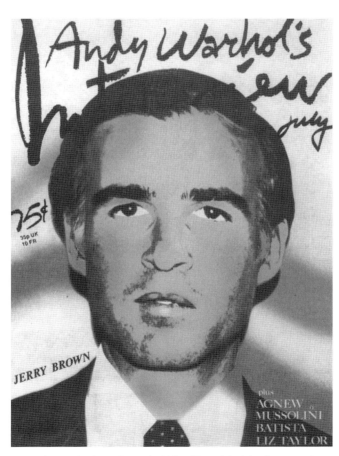

FIGURE 6: Portrait of Jerry Brown by Richard Bernstein, *Interview* magazine, vol. 6, no. 6, July 1976. The Archives of The Andy Warhol Museum, Pittsburgh. Founding Collection, Contribution The Andy Warhol Foundation for the Visual Arts, Inc.

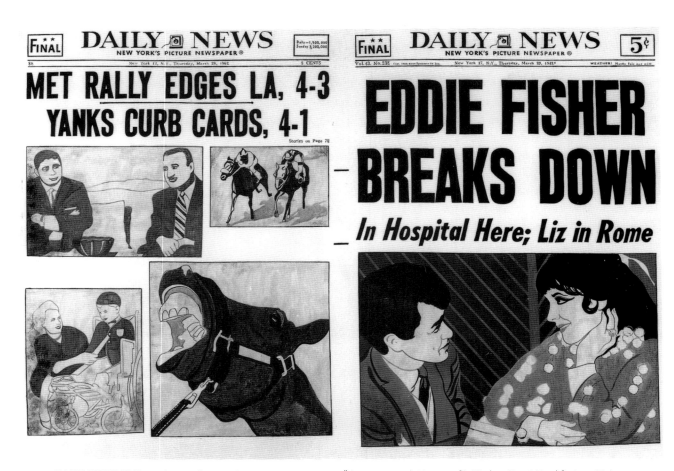

FIGURE 7: **DAILY NEWS**, 1962. Synthetic polymer paint on canvas, 80 1/4 x 100" (183.5 x 254 cm). Museum für Modern Kunst, Frankfurt am Main, Germany. Ehemalige Sammlung Ströher, Darmstadt

> [The Marcos commission] could [have been] the big break in his campaign to become the official portraitist to the leaders of the world. And, unlike President Ford, or any other leader of a democratic nation, Imelda Marcos really could order up scores of her silk-screened like-ness, for every cabinet member's office, governor's mansion, and ambassador's residence, fulfilling one of Andy's fondest fantasies: the single commission that miraculously multi-plied ad infinitum.[28]

For every one of Warhol's political moves, there were scores of others that were seemingly apolitical, most of them motivated by his unabashed drive for fame and financial gain.

When Warhol reproduced on the cover of *Interview* notable people in the political arena, including then-Governor Jerry Brown of California (figure 6), Imelda Marcos, Nancy Reagan, and Farah Dibah Pahlavi, the Empress of Iran, was he simply documenting their roles in contemporary politics, implying approval of the various political positions they represented, showcasing the glamour of political life—or some combi-nation of these three possibilities?[29] Because of Warhol's intractable ambivalence, the question inevitably becomes rhetorical. Nevertheless, it is clear that his extensive involvement with political life was made possible in part by his lack of political scruples.

Warhol read the daily newspapers and scanned the **Cover Stories** every day. When he could not, he asked other people to read them for him, offering small rewards for any additions to his scrapbook of gos-sip in which he was mentioned. He was fascinated by newspapers, which provided the inspiration for a loosely connected series of work that spanned his entire career. Among the best known are the early hand-painted cover stories, such as *Daily News* (1962), which documents pop singer Eddie Fisher's break-down and refers to his then-wife Liz Taylor's collapse on a Hollywood set, in 1961, from a near-fatal illness (figure 7). Throughout his career, Warhol worked in this genre, not only for his own artistic purposes but

also for special commissions, such as the screenprint on paper *Daily News* (ca. 1967), which he created for an unrealized *New York Daily News* ad campaign (figure 41).[30]

This exhibition features some of Warhol's experiments with the cover-story genre that have never before been shown in a museum. These include three canvases representing the first, second, and third pages of the *New York Post,* dated October 24, 1983, which document the bombing of U.S. Marines in Beirut, Lebanon (ca. 1983; figures 44–46). One wonders if it was the bombing itself that caught Warhol's attention and spurred this blunt, textual snapshot of current events, or if it was the headline spanning the top of the front-page canvas, which announced the death in a car crash—a long-standing Warhol preoccupation—of the nationally televised newscaster Jessica Savitch, whose personal life and career were covered regularly in the tabloids. After Savitch's appearance on the first page of this triptych, there is no further mention of her. Page two includes more mundane components of the newspaper, such as the index and lottery results, tempering the shock of the front-page headlines. Warhol was most certainly fascinated by this particular edition of the *New York Post*, which would serve as the inspiration for a number of works made around 1983. But the evenness of his attention to the contents of the first three pages, implied by his disinterested recording of both memorable and forgettable news items, dilutes the tragedy that must have attracted him in the first place. In classic deadpan fashion, Warhol's reproduction techniques belie his interest in the subject they are used to depict. Once again, we are left stranded in the interstitial realm between the hard-and-fast surface and the possibility of the artist's profound empathy for what that surface represents.

The exhibition's one featured sculpture, *Abstract Sculpture* (1983), is a little-known screenprint on crumpled Mylar that uses the same *New York Post* cover story to document the bombing of Marines, but does so in a way that suggests the tabloid was actually in Beirut, where it was mangled as a result (figure 42). An experimental offshoot of this work are the four painted canvases, also titled *Abstract Sculpture* (ca. 1984), that likewise document the tragic assault that killed almost 200 Marines (figure 43). The actual inspiration for these objects, however, was not the crumpled Mylar *Abstract Sculpture*, but probably a similar work on crumpled canvas, with the same title, in the collection of The Andy Warhol Museum. Warhol photographed the related, seemingly mutilated canvas sculpture of a cover story and had a silkscreen made from the photographic image, which he subsequently used to create the four paintings in different colors. Still visible in the jumbled pictures are the same horrifying headlines—a meeting ground of abstraction and hard-nosed journalism that points in a creative direction that ended with these works.

The exhibition's final three categories—**Advertising**, **Celebrity**, and **Symbolism**—further document the case for Warhol's role as a latter-day documentarian who parlayed the traditional concerns of Social Realism into his media-based aesthetic. Warhol made the objects in the Advertising section from photographic or Photostat enlargements of both well-known and obscure ads, as well as other trivial images found in newspapers and magazines. *Before and After* (1961) is an early example with autobiographical overtones in light of Warhol's preoccupation with the size of his nose (figure 50). It is also a wry commentary on a cosmetic procedure relatively common in a certain social echelon.

Warhol's affinity for advertising imagery continued until the end of his career, when he embarked on two major series—one in the guise of color ads and the other black-and-white—which combined his abiding interest in celebrity, politics, and autobiography. *Van Heusen (Ronald Reagan)* (1985) was made during the subject's presidency, but it features Reagan in his earlier incarnation as a movie star promoting a brand of men's shirts (figure 48). The artist's autobiographical impulse resurfaces again in the anonymous public space of the printed mass media in *Total* (ca. 1985), a drawing of an advertisement for a girdle, an undergarment Warhol was forced to wear after he was shot in 1968.

In the exhibition, Warhol's symbols—Dollar Bills, Hammers and Sickles, Knives, Guns, and Dollar Signs—are installed in proximity to his celebrity portraits to highlight the violent and consumerist subtexts of those portraits. Although these subtexts have been addressed in the art-historical literature, such as in the writings of Crone, Crow, and Buchloh, they have often been difficult to apprehend when the works are seen individually or outside the context of Warhol's entire oeuvre. For example, the Akron Art Museum's gun-toting *Single Elvis* (1963; figure 54), viewed in proximity to a late "Gun" painting (figure 62),

takes on an added, unsettling dimension that our reverence for the superstar may cause us to ignore. Indeed, it is our veneration of the myths of American popular culture that Warhol so famously fostered—whether Elvis, Marilyn, or O. J.—that is called into question when looking at these icons in this fresh context. What may in some cases seem to be benign memorials and in others manifestations of our admiration become, more clearly, representations of our society's darker side, where death and violence fan consumerist desires.

An exploration of Warhol's preoccupations as a social observer will perhaps not yield consistent estimations of his critical tendencies or wholly satisfying answers regarding his commitments, affiliations, and sympathies. Nonetheless, pertinent connections do emerge. Warhol is notoriously slippery as a subject for analysis. The significance of his individual artworks can be as unwieldy as his influence is imposing. The expansive ability of his work to manifest and critique the social order as a system of commodity exchange invests it with the potential for a wide variety of readings.

One especially striking interpretation was proffered, in 1975, when Warhol exhibited "Ladies and Gentlemen," his portrait series of black transvestites, in an art gallery in Ferrara, Italy. "The left-wing Italian art critics," recalls Colacello, "went wild, writing that Andy Warhol had exposed the cruel racism inherent in the American capitalist system, which left poor black and Hispanic boys no choice but to prostitute themselves as transvestites."[31] These critics assumed, approvingly, that Warhol was a Communist because they had perceived his paintings of New York club life as a critique of American culture. Warhol found inspiration in their comments. Later that night, following the opening in Ferrara, he returned to his hotel with Colacello, who relates that the artist said, "Maybe I should do real Communist paintings next. They would sell a lot in Italy."[32] In the end, they—the "Hammer and Sickle" paintings—did sell a lot.

For Warhol, social observation was a complex system of relationships: a way to mediate his interactions with the world, exploit the social matrix, discover what people want, and, no less important, how to make them pay for it. His extraordinary ambivalence provides a unique critical vantage point from which to explore these tightly related phenomena and to understand how they inform America's social order. By examining his socially and politically relevant subjects, it is clear that there is still much to be learned about Warhol, as well as ourselves, even if what we learn leaves us feeling somewhat like the artist—ambivalent. In the end, Warhol did care about people, politics, and current events, and, from time to time, he did choose sides. But it is also fair to conclude that he probably would have preferred not to. As he once stated, "It would be so much easier not to care."[33]

Notes

1. Andy Warhol, as quoted in Richard A. Ogar, "Warhol Mind Warp," *The Berkeley Barb*, 1–7 September 1968, n.p.; as cited by Benjamin H. D. Buchloh, "The Andy Warhol Line," in *The Work of Andy Warhol*, "Discussions in Contemporary Culture" series, ed. Gary Garrels, no. 3 (Seattle: Bay Press, 1989), 60.

2. Andy Warhol, as quoted in Gretchen Berg, "Nothing to Lose: Interview with Andy Warhol," *Cahiers du Cinema* (English edition) 10 (May 1967): 40.

3. Thomas Crow, "Saturday Disasters: Trace and Reference in Early Warhol," in *Modern Art in the Common Culture* (New Haven: Yale University Press, 1996), 49–65.

4. Ibid., 65.

5. Richard Weisman, the investment banker and son of Los Angeles collectors Freddy and Marcia Weisman, commissioned Warhol to create the "Athletes" series for a total of $800,000. The works were shown in New York, London, Toronto, and Cologne but, as Bob Colacello, Warhol's biographer, recounts, "Everywhere the art critics yawned and the sports fans wondered why Andy had painted O. J. Simpson in pistachio and cantaloupe." It was Weisman, eager to recoup some of his original investment, who asked Warhol to exhibit with LeRoy Neiman in 1981 at the Los Angeles Institute of Contemporary Art. The reasons for the joint exhibitions with Wyeth in New York, Chadds Ford, Nashville, and Monte Carlo are less clear. The artists were friends, painted each other's portraits, and Warhol apparently proposed a joint exhibition of these depictions in early 1976. Warhol also exhibited with Jean-Michel Basquiat in the 1980s. On the "Athletes" series, see Bob Colacello, *Holy Terror: Andy Warhol Close Up* (HarperPerennial, 1990), 340; and on Warhol's relationship with Wyeth, see Joyce Hill Stoner, "Andy Warhol and Jamie Wyeth: Interactions," *American Art* 13 (Fall 1999): 61.

6. Lawrence Weschler, "The Looking Glass," *The New Yorker*, 31 January 2000, 66.

7. According to Colacello, Warhol agreed to the title *Exposures* when the bookstore chain B. Dalton stated that it would buy fewer copies of the publication if it were titled *Social Disease*. The original cover design was "a black-

and-white snapshot of Jackie Onassis and Bianca [Jagger] visiting Liza [Minnelli] backstage with *Social Disease* stamped across it in bright red." Colacello, *Holy Terror*, 420–21.

8. Warhol created more than 600 "Time Capsules," and he collected every *New York Post* front page beginning in 1968. Colacello, *Holy Terror*, 294.

9. *Andy Warhol: Social Observer* premiered at the Pennsylvania Academy of the Fine Arts, Philadelphia, in conjunction with the retrospective *Robert Gwathmey: Master Painter*, organized by the Butler Institute of American Art. The idea was to pursue this line of reasoning through the dual presentation of the exhibitions. From a related critical vantage point, Stephen Koch proposed early on that Warhol was a social voyeur. See the two monographs by Rainer Crone: *Andy Warhol*, translated by John W. Gabriel (New York: Praeger Publishers, 1970), and *Andy Warhol: A Picture Show by the Artist* (New York: Rizzoli International Publications, 1987); the latter was originally published as *Andy Warhol: Das zeichnerische Werk 1942-1975* (Stuttgart: Württembergischer Kunstverein, 1976). Also see Stephen Koch, *Stargazer: Andy Warhol's World and His Films* (New York: Praeger, 1973).

10. Buchloh, "The Andy Warhol Line," 60.

11. Colacello, *Holy Terror*, 111.

12. For a concise discussion of the economics of Warhol's reproduction-based art-making techniques, see Arthur Danto, "Warhol and the Politics of Prints," in *Andy Warhol Prints: A Catalogue Raisonné 1962–1987*, 3rd ed., revised and expanded by Frayda Feldman and Claudia Defendi (New York: Ronald Feldman Fine Arts, Inc., Edition Schellmann, The Andy Warhol Foundation for the Visual Arts, Inc., 1997), 8–15.

13. This idea comes from another of Thomas Crow's essays, "Art Criticism in the Age of Incommensurate Values: On the Thirtieth Anniversary of *Artforum*," in *Modern Art in the Common Culture*, 93.

14. Andy Warhol, *THE Philosophy of Andy Warhol (From A to B and Back Again)* (New York: Harcourt Brace & Company, 1975), 62.

15. Colacello, *Holy Terror*, 89.

16. Gerard Malanga, in Patrick S. Smith, ed., *Warhol: Conversations about the Artist* (Ann Arbor: UMI Research Press, 1988), 162.

17. Andy Warhol, as quoted in G. R. Swenson, "What is Pop Art?," *Art News* 62 (November 1963): 26.

18. The above discussion about process comes from Malanga, in *Warhol: Conversations about the Artist*, 164.

19. Crow, "Saturday Disasters," 61.

20. Colacello, *Holy Terror*, 111.

21. Nan Rosenthal identifies the inspiration for Warhol's *Vote McGovern* print as Ben Shahn's offset lithograph *Vote Johnson*, produced in an edition of 500 on behalf of the 1964 Barry Goldwater presidential campaign. Nan Rosenthal, "Let Us Now Praise Famous Men: Warhol as Art Director," in *The Work of Andy Warhol*, ed. Garrels, 43.

22. Colacello, *Holy Terror*, 111.

23. Ibid., 110.

24. Ibid., 284.

25. The Shah was not yet deposed at the time. Warhol Scrapbook, vol.12 large, 1973–77, 12; *Village Voice*, 14 November 1977. Archives of The Andy Warhol Museum, Pittsburgh.

26. Colacello, *Holy Terror*, 257.

27. Ibid., 118–19.

28. Ibid., 271.

29. In *The Work of Andy Warhol*, ed. Garrels, 129–33, the transcribed panel discussion touches on this issue.

30. Nan Rosenthal reminds us that Warhol was not the only artist of his generation to find inspiration in newspaper cover stories. In 1960 the French artist Yves Klein appropriated the Paris paper *Dimanche*, portraying himself on a faux front page apparently making a swan dive into the street from the window of a building. Rosenthal, "Let Us Now Praise Famous Men," 37.

31. Colacello, *Holy Terror*, 228.

32. Ibid.

33. The full quote is: "I still care about people, but it would be so much easier not to care, it's too hard to care." Quoted in Berg, "Nothing to Lose," 42–43; as cited by Trevor Fairbrother, "Skulls," in *The Work of Andy Warhol*, ed. Garrels, 101.

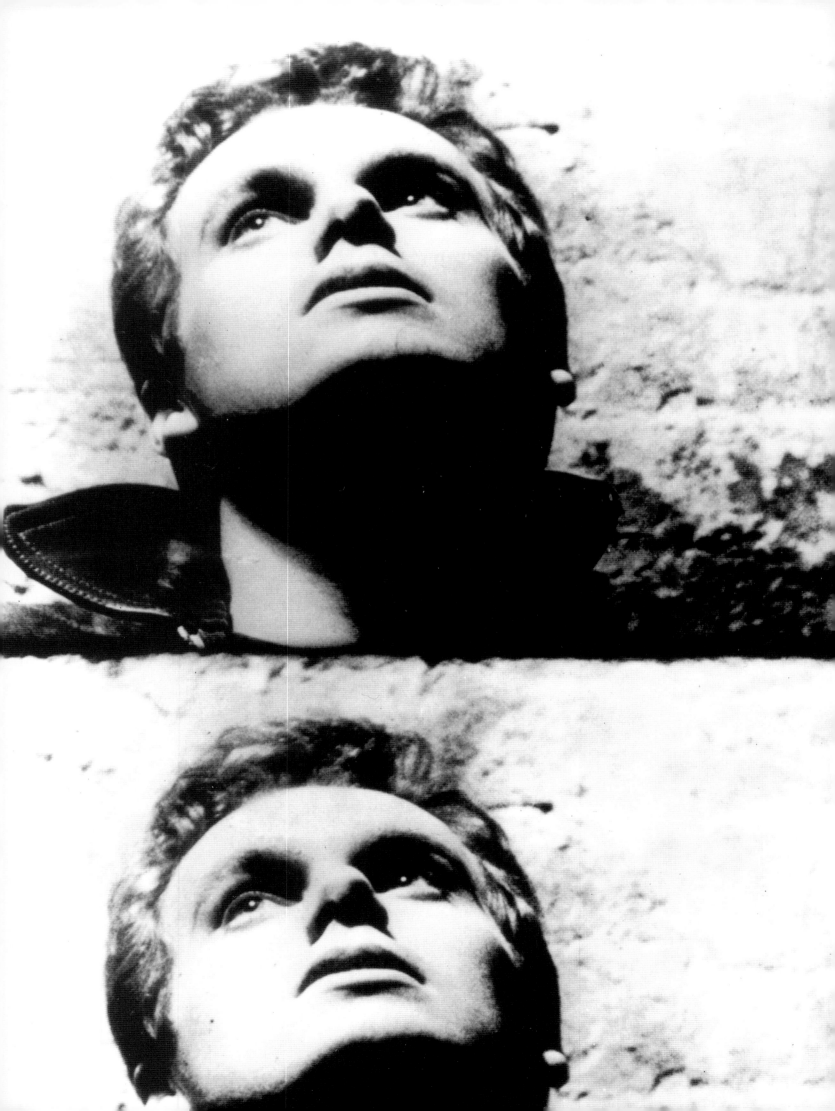

Andy Warhol's "Pleasure Principle"

MAURICE BERGER
Senior Fellow
The Vera List Center for Art and Politics, New School for Social Research

The camera is drawn to the angelic, boyish face. In stark black-and-white and in silence, it searches out every visual detail that foregrounds the beauty of his countenance: the raking light that throws shadows across it, the hard brick wall that frames it, the shock of wavy hair that caresses it. The purposeful camera locks in above the neck, tracking the young man's every expression and movement. The head tilts right. Then left. Then right. The facial muscles tighten. Then relax. The eyes close. The eyes open. The eyes drift off into a glazed stare. For the next thirty-five minutes, the camera keeps an unblinking vigil over its pretty subject. The head tilts right. Then left. Then forward. The eyes close. The eyes open. Then it is over. The eyes narrow to slits. The muscles of the face tighten into a grimace. The head shoots backward. The veins of the neck bulge. The sensuous lips part, releasing guttural but unhearable sounds.

The above action is the sole content of *Blow Job*, a film directed by Andy Warhol in 1963 (figure 8). It is an audacious piece of cinema, surely one of the most consequential aesthetic acts of the early 1960s. In a number of ways, this film—along with Warhol's other films, paintings, and sculptures of the period— tells us much about the culture and politics of the time in which it was made. It has become almost a cliché to say that Warhol was the quintessential artist of the early and mid-1960s, the chronicler of media fascinations, and the observer who, by replicating and then repeating the images of best-selling products or publicity shots of the famous, captured the ubiquitousness and power of the media in the everyday lives of Americans. But there was another side to Warhol's art and milieu, a darker, more daring side that placed him at the forefront of the progressive politics and culture of his day.

This is not to say that making a case for Warhol's social engagement is easy. The artist repeatedly asserted that he was indifferent to politics, vacillated in his political beliefs, and had no point to make in his art. In 1968, responding to the question of whether he was apolitical, Warhol said, "The reason I don't sort of get involved...is because I sort of believe in everything. One day I really believe in this, and the next day I believe in doing that."[1] Some left-leaning critics have scolded Warhol for his decided lack of ideology: to them, he was nothing more than an impressionable, glib, and star-struck naïf seduced by the very money and power his work appeared to critique. They cite his own words—"Good business is the best art"—and his later friendships with such reactionary figures as Imelda Marcos, Nancy Reagan, and the Shah of Iran. Neoconservative critics have argued that Warhol's art is reflective of the decline of civilization itself.[2] In their eyes, the artist was a cynic who preyed on society's desire for celebrity, vulgarity, and gossip in order to sell work that is itself vulgar, exploitative, and sycophantic.[3]

Was Warhol, then, a "political" artist? The answer is both complex and contradictory. If it is true, as one critic wrote, that Warhol's work maintained a "consistently ambivalent relationship to both mass culture and high art," then his politics may be no more consistent or logical than his apparent lapses in political judgment.[4] Thus it might be more interesting to shift the inquiry into Warhol's social engagement away from issues of intentionality to that of effect, to the question of whether Warhol's art actually has social or ideological significance.

Compelling answers to this question thus far arise from examinations of Warhol's paintings from the early 1960s. Hal Foster, for example, has argued that works such as *Ambulance Disaster* (1963), *White Burning Car III* (1963), and *Race Riot* (1964; figure 25) represent a kind of "traumatic realism" that not only reproduces disturbing and violent events (a mangled body hanging out of the window of a crashed ambulance, a crash victim impaled on a telephone pole, a policeman beating a civil rights protester with a club) but also produces them through various technical devices.[5] Thomas Crow points to the early paintings as powerful markers of Warhol's social engagement. Their confluence of radical formal devices and the repetitive appropriation of everyday media images of death and disaster, Crow reasons, result in a kind of *pein-*

FIGURE 8: **BLOW JOB**, 1963. 16 mm film still. The Museum of Modern Art Film Archives, New York

ture noir, a visual parallel to the *film noir* genre of the 1940s and '50s that offers "a stark, disabused, pessimistic vision of American life, produced from the knowing rearrangement of pulp materials by an artist who did not opt for easier paths of irony or condescension."[6]

In the context of both of these arguments, it is difficult to imagine how such paintings, exhibited in the elitist space of the avant-garde and dependent on a traditional relationship between an informed spectator and a static, two-dimensional image, could on their own have had much of a political impact. But Warhol was never just a painter. He was an artist who continually pushed the envelope of artistic practice. His most important political and cultural legacy resides, as Crow himself implies, in the work he sanctioned "in non-elite culture far beyond the world of art."[7] In fact, it is impossible to fully understand Warhol's art as a whole, including his paintings, without examining these works. To ignore them, especially Warhol's extraordinary films, is to miss the relationship between radical aesthetic experimentation and ideology itself. To ignore them is to erase Warhol's connection to other, equally radical sectors of avant-garde culture in the 1960s, as well as to the cultural underground that existed outside of the art world. To ignore them is to misread the ways in which Warhol's influence helped shape the cultural and political zeitgeist.

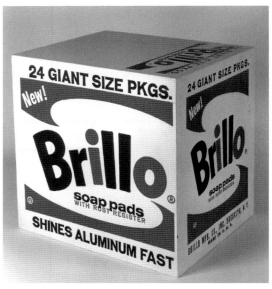

FIGURE 9: **BRILLO BOX**, 1964. Synthetic polymer paint and silkscreen on wood, 17 x 17 x 14" (43.2 x 43.2 x 35.6 cm). The Andy Warhol Museum, Pittsburgh. Founding Collection, Contribution The Andy Warhol Foundation for the Visual Arts, Inc.

Warhol attempted to break through the conventions and constraints of painting to more temporal and performative expressions. As early as the late 1950s, he had placed paintings on the sidewalk and watched as people stepped on and over them. His "Dance Diagram" series (1962), paintings of stylized footprints lifted from a ballroom-dancing instruction book, not only alludes to the act of dancing itself but tempts the viewer to follow the footsteps on canvases that are exhibited directly on the floor (figure 10).[8] Warhol also began making sculpture in 1964, a series of wooden re-creations of the cardboard boxes used to ship Brillo Soap Pads, Heinz Ketchup, Campbell's Tomato Juice, and Del Monte Peach Halves to supermarkets (figure 9). These minimal, monolithic forms, scattered or grouped on the floor throughout the gallery space, invited spectators to move in and around them. The artist's cerebral and optical Pop strategies thus merged with the phenomenological tactics of Minimalism, where prefabricated plinths, tiles, and cubes made of industrial materials such as steel, copper, and lead were also discharged into gallery space, allowing viewers to interact with objects free of pedestals and other distancing devices.

By the early 1960s, Warhol appeared to be restless, stymied by the conceptual and phenomenological limits of the art object. A similar frustration impelled many avant-garde visual artists of the period—including Joseph Beuys, Jim Dine, Allan Kaprow, Yves Klein, Robert Morris, Bruce

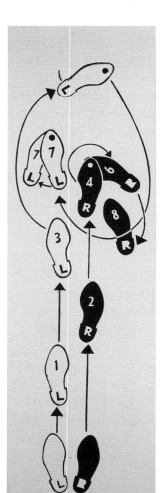

FIGURE 10: **DANCE DIAGRAM**, 1962. Acrylic, pencil, and masking tape on canvas, 83 x 24" (210.8 x 60.9 cm). The Andy Warhol Foundation for the Visual Arts, Inc., New York

Nauman, Claes Oldenburg, Nam June Paik, Richard Serra, and Robert Rauschenberg—to experiment with performance, dance, video, and film. "Using up images so fast that he was feeling exhausted of the imagination," Warhol turned for inspiration in 1963 to the medium of film.[9] Ironically, by the time his first show at the Leo Castelli Gallery opened in November 1964, the artist had, for the most part, abandoned painting in favor of filmmaking. Between 1963 and 1968, Warhol directed nearly sixty films, producing one of the most influential and consequential oeuvres of avant-garde cinema in the twentieth century. His interest in film was shaped by his friendships and encounters with key figures in avant-garde theater and film. At Ronald Tavel's Theater of the Ridiculous, for example, he met the actor Taylor Mead, a veteran of underground films, who later accompanied him to California, where Warhol would befriend transgressive filmmakers Jonas Mekas and Jack Smith. Warhol regularly attended screenings of avant-garde movies at the Film-Makers' Cinematique in New York, where his first films were later premiered.[10]

The repetitive, framelike arrangements of Warhol's early paintings suggest that he was thinking about cinematic form even before he began making movies. In 1963, just before he directed his first film, the artist silkscreened onto paper a film still from a Dracula movie to create *The Kiss (Bela Lugosi)* (figure 11). Warhol's first films were exercises in Minimalist restraint. Fixed in both focus and point of view, they are soundless and projected not at the standard sound speed of 24 frames per second, but at silent speed, 16 fps—thus further "retarding the[ir] minimal action."[11] They focus on simple human actions, most often with sexual overtones: *Sleep* (1963) shows the poet John Giorno sleeping over a six-hour period; *Kiss* (1963) features close-up sequences of different couples kissing; *Eat* (1963) documents the artist Robert Indiana eating a single mushroom over a forty-five-minute period (figure 12); *Empire* (1964) is a static, eight-hour film of the Empire State Building, shot from dusk on July 25, 1964, to the next morning (figure 60). In 1964 Warhol moved from silent footage and a fixed, stationary camera to full-fledged cinematic narratives, technically driven by zooms and pans and later by advanced editing strategies such as strobe effects. In films such as *Harlot* (1964), *My Hustler* (1965), *Vinyl* (1965; figure 13), *The Velvet Underground and Nico* (1966), *The Chelsea Girls* (1966), *I, a Man* (1967), *Lonesome Cowboys* (1967), and *Flesh* (1968), the artist explored the lurid, often homo-erotic or sadomasochistic side of the cultural underground that surrounded and fascinated him.

The early films allowed Warhol to appeal to the viewer in ways that were almost impossible with paint on canvas. Projected in the dark, the films have an intimacy, a texture, and a humanness

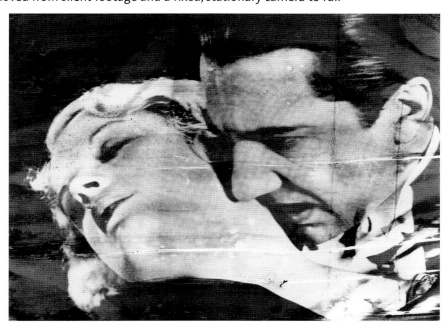

FIGURE 11: **THE KISS (BELA LUGOSI)**, 1963. Silkscreen on paper, 30 x 40" (76.2 x 101.6 cm). Philadelphia Museum of Art. Gift of William M. Speiller

different from the flat and frosty hipness of Warhol's paintings based on images appropriated from the media. Unlike the paintings—which are essentially information-oriented, process-driven, and rich with cultural codes addressed mostly to the eye and mind—the films, like his sculptures of 1964, proffer an almost phenomenological relationship to the spectator: their pure, voluptuous sensuality elicits a visceral rather than an intellectual response. They are often unabashedly erotic, manipulative, and even sexually arousing, evoking a powerful physiological response that is almost outside of language and ideas.

Even in the early paintings, one senses Warhol's impatience to break free of cultural and art-historical conventions to reach more visceral states of being. Both the early paintings and the films share a kind

of compositional and cinematic invariability, a regularized, allover structure that allows them to unfold without high and low moments, or, for that matter, without climax. The sight of hundreds of Coca-Cola bottles, identical and lined up row after row, or a fixed view of the Empire State Building or of a man sleeping over an extended period of time has neither a narrative payoff nor a punch line. Warhol's art of this period is tinged with pathos, full of intimations that he was repeating and exhausting the possibilities of visual representation. Images tend to fall back on themselves, condemned to give the same information over and over again like an autistic child, rocking back and forth, uttering the same words repeatedly until they become meaningless.[12]

The early paintings, dependent on a static canvas surface onto which Warhol silkscreened identical images of brand-name products or celebrities, made this kind of disconnection from cultural conventions more difficult. Warhol's early films, on the other hand, are almost pre-media, or, more accurately, preverbal. They represent basic physical, transitive states in which language and representation can do us little good. As if to contradict the mind-set of the early paintings, these films depict states of being liberated from the hyperconscious, hypercritical realm of the media: endless, silent hours of people primping, sleeping, sucking, writhing, devouring, lusting, ejaculating, without the intervention of language, narrative, or commentary. Films such as *Sleep, Kiss,* and *Blow Job* return us to the primal scenes of our psyche, the id that exists for the sole purpose of gratifying desire and pleasure, without concern for social consequences. In Freudian terms, it is as if Warhol suspends the power of the superego—the psychological generator of societal conventions, order, and moral codes rooted in language—which censors our basest, most socially unacceptable urges. It is this preverbal, infantile impulse to satisfy the instincts of sexuality and pleasure that Sigmund Freud named the Pleasure Principle. And it is precisely the play of these pleasurable and base instincts that Warhol celebrates in his early films.

The early films constitute a visual universe of raw sexuality, sensuality, and pleasure, an aesthetic realm also tinged with the psychosexual flip side of sex—violence and death. They reverberate with points of sheer, exuberant eroticism: the sight of Giorno's thick, bare chest as it rises and falls to the rhythm of his breathing in *Sleep;* the split-second glimpse of a penis as the naked cowboy uncrosses his pale, sinewy legs in *Haircut* (1964); a pair of sensuous lips being parted by an eager tongue in *Kiss;* the upturned collar of Gerard Malanga's leather jacket in *Blow Job,* a hint of the sadomasochistic thrill that lies just below the surface of the young man's all-American, choirboy countenance. In the context of these films, one realizes the extent to which the early paintings strove to bring a similar erotic rawness to the surface. Their compulsive repetition, itself a kind of cinematic conceit, became a way of relentlessly hitting us with provocative triggers of desire or fascination—Elvis's gun-toting hips (*Single Elvis,* 1963; figure 54), Marilyn's luscious lips (*Marilyn Monroe's Lips,* 1962), Troy's golden blond hair (*Troy Donahue,* 1962), a crash victim's severed throat (*Ambulance Disaster,* 1963), or an electric chair's menacing leather straps (*Little Electric Chair,* 1965; figure 23).

How, then, is this play of the pleasurable and the sexual in Warhol's early work political? Why is Warhol's desire to represent our basest psychosexual instincts a progressive rather than a regressive act? The answer to this question rests with the intellectual and cultural zeitgeist of the 1960s. Social ideals such as equality, liberation, or sexual freedom—goals that, to one extent or another, drove almost every significant political movement of the period, including feminism, civil rights, and gay and lesbian rights—underwrote a kind of popular, countercultural politics. This countercultural thinking pervaded both high and popular culture, influenced by a range of social theorists and critics, from R.D. Laing to Norman O. Brown and Timothy Leary, who were advocating the power of the id to "desublimate" the ego from repressive social norms, to free the individual from the constraints of bourgeois values.

Perhaps no theorist was a more influential advocate of the desublimatory spirit of the 1960s than Herbert Marcuse. His treatises were widely read and discussed by European and American activists, intellectuals, and cultural figures, eventually trickling down to popular cultural discourse. His much debated *Eros and Civilization* (1955), a bible of sorts for artists and intellectuals of the late 1950s and '60s, argued for the need to overthrow the societal ideal, most notably espoused by Freud, that orients human interaction toward labor and productivity. Marcuse questioned the value of a work ethic built on the notion that

the individual must sacrifice pleasure and the libido (the id) in favor of those aspects of our unconscious and conscious mind that allow us to be socially productive (the ego and superego). Within that Freudian ideal, a labor-based economy functions efficiently only when workers are coaxed away from sexuality and play and toward gainful, revenue-producing toil. For Marcuse, it was precisely this acquired "self-repression"—so central to capitalist society that it has been handed down from one generation to the next like the tenets of law—that inhibited individual freedom and expression.[13]

Marcuse advocated the idea of "libidinal labor"—work that was analogous to sex and pleasure because it served the personal, political, and emotional interests of the individual rather than those of the institution. He also maintained that the battle to save the worker from an alienated, oppressed life would also be fought on the turf of sexual freedom. Marcuse called for a politics of desublimation, an antirepressive ideology that favored sexuality over chastity, independence over allegiance to the institution, and—in a concept that would be central to many artists of the 1960s—the body as an instrument of self-expression and gratification. In an essay on aesthetics, Marcuse argued for the desublimatory power of art and art-making, concluding that "aesthetic liberation" would become an important part of the battle for freedom. Artists' traditional reliance on rational form, compositional balance, and art-historical allusion, he believed, resulted in dogmatic work that was neither liberating nor revolutionary. Calling for a "revolution in perception, a new sensorium," Marcuse imagined a material and intellectual reconstruction of society rooted in a new aesthetic environment.[14]

Cultural radicals of the late 1950s and early '60s often strove to arrive at this "new sensorium," creating a transgressive art that embraced sensuality and pleasure, if not sex itself, as a path to liberation. A broad range of cultural producers, acting through many different institutions, media, and theoretical influences, joined the forces of art to those of the sexual revolution. Early on, the stark, uncompromising writings of Beat gurus Allen Ginsberg, Jack Kerouac, and William Burroughs served as the rallying cry for those who believed in the power of drugs and sex to liberate people from bourgeois society's repressive rules and norms; in the world of avant-garde cinema, Kenneth Anger, Bruce Connor, and Jack Smith directed dark, drugged-out reveries on bohemian exoticism, sexual decadence, and erotic violence; at the dawn of postmodern dance and performance, Carolee Schneemann navigated through the interconnected realms of sex, violence, and death in *Meat Joy* (1964), a work that featured near-naked performers rolling around and wrestling

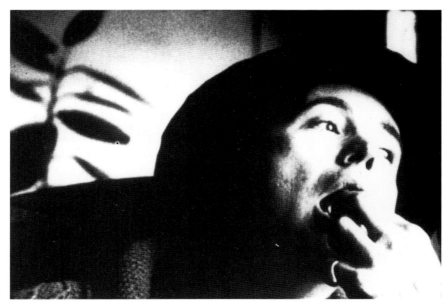

FIGURE 12: **EAT**, 1963. 16 mm film still. The Andy Warhol Museum, Pittsburgh. Founding Collection, Contribution The Andy Warhol Foundation for the Visual Arts, Inc.

with one another on a stage covered with raw meat; at the edge of the popular music world, the Velvet Underground performed "Venus in Furs" and "Heroin," sultry, narcoleptic anthems to sex, drugs, and rock 'n' roll; and, as if to blur the distinction between avant-garde theater and pornography, Michael McClure had Billy the Kid go down on Jean Harlow in his play *The Beard* (1965), a vivid fantasy that foregrounded the sexual allure of these American icons.

Warhol unquestionably contributed to this countercultural moment. His proximity to the sexual and drug subcultures, as well as the erotic fascinations of his paintings and the open sexuality of his films, makes this relationship manifest. Not surprisingly, one of Warhol's first films is a documentary of the mak-

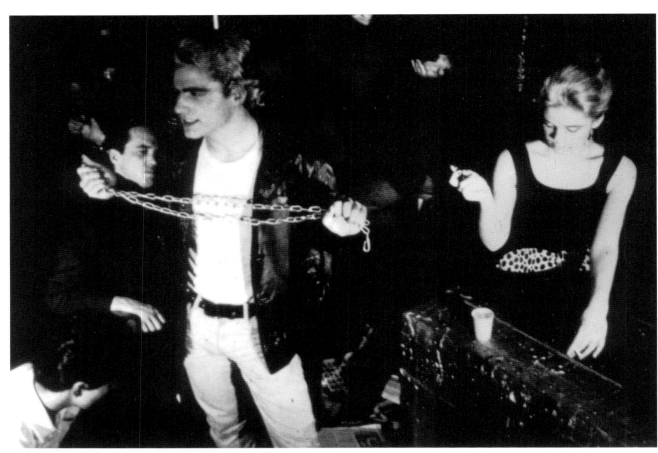

FIGURE 13: **VINYL**, 1965. 16 mm film still. The Museum of Modern Art Film Archives, New York

ing of *Normal Love* (1963), the ironically titled Jack Smith film that pushes the limits of liberal taste. A year later, Smith would act in one of Warhol's films, *Batman Dracula* (1964). In the late 1950s and early '60s, filmmakers like Smith were beginning to establish a connection "between underground art and the sexually misbegotten."[15] Warhol, more than any other artist of the period, established yet another level of association: that between the world of underground sexuality and art and the safer, more profitable realm of bourgeois culture. The Factory, Warhol's studio with silver-covered walls on East Forty-seventh Street in Manhattan, was the proverbial ground zero of this liaison, a place where "interlocking subcultures—artistic, sexual, sometimes even criminal—were able to at last surface into the bright glamour of the 1960s affluent chic," a glistening universe where hustlers mingled with museum curators, prostitutes with studio assistants, transvestites with socialites.[16]

In *THE Philosophy of Andy Warhol*, the artist said that he "loved" every liberation movement, "because after the 'lib' the things that were always a mystique become understandable and boring, and then nobody has to feel left out if they're not part of what's happening."[17] Warhol's obsessive repetition of the erotic, the profligate, or the forbidden suggests the crux of his "politics": the desire to liberate the aesthetic experience, and perhaps sexuality itself, from normative and repressive values. In Warhol's Factory, the seamier, darker side of modernism—the brash prostitute of Edouard Manet's *Olympia* (1863), the horny bachelors of Marcel Duchamp's *Large Glass* (1915–23), and the homoerotic, hard-on sporting studs of Charles Demuth's *Three Sailors on a Beach* (1930)—came out of the closet, out of the hypocritical safety of avant-garde painting and sculpture and into real-life cultural interactions. Warhol would no longer bow to moral codes that deemed heterosexuality as normative, homosexuality or sadomasochism as aberrant, and hookers and hustlers as pathetic, immoral, and self-destructive. In a play on Freud's repetition compulsion, he repeated erotic or disquieting images not to stave off the instincts in order to control and overcome them, but to reiterate them until they became "understandable and boring."

Thus Warhol's art strove to disconnect the viewer from normative thinking while simultaneously pushing the limits of bourgeois acceptability. Stephen Koch has observed that in Warhol's *Vinyl* (1965)—the first cinematic adaptation of Anthony Burgess's novel *A Clockwork Orange*—Gerard Malanga, posing as rough trade, goes through the motions of sadomasochistic acts, "sex that flexes its muscles, fills its chest, grimaces and then...holds still," stopping at the point where his eroticism might slip into the realm of the grossly violent (figure 13).[18] Of this aesthetic game, Koch continues:

> Warhol's filmic language in *Vinyl* involves itself in the horrors that underlie the 1960s' frenzied grace and frozen hysteria. And, as in all of Warhol's best films, the effects seem to be located in an extraordinary cinematic distance from our perceptions. This distance was literalized the first time I saw the film up near the ceiling of that huge dance hall. 1965 was a moment in Warhol's career marked by something that can be called perfect taste—special and perhaps unattractive, but perfect taste.... The struggle of *Vinyl*'s static pictorialism with movement is ideally viewed through a distracted awareness. One does not precisely watch the film, but rather one looks at it and then looks away again. Attention is held, only to be released and taken again.[19]

In Warhol's films the viewer is given the psychic distance necessary to absorb the things that would normally be too shocking or disturbing. The homoerotic and pornographic overtones of *Blow Job*, for example, are tempered by the artful cropping out of the film's real center of attention: the fellated penis and its servicer. In *Eat*, the act of eating a mushroom is attenuated to such a degree that multiple interpretations become possible, from obvious (a man eating a mushroom), to heady (a man getting high on mushrooms), to licentious (a man giving head). The deadpan zaniness of *Harlot* (1964), Warhol's first sound film, offers comic relief from the obvious sexual metaphor of Mario Montez lasciviously devouring banana after banana, while Carol Koshinskie sits nearby, holding a small dog in her lap and staring into the distance, stupefied with boredom. And in *Beauty #2* (1965), Warhol employs a subtle though implicit comparison to defy cultural norms about beauty and nudity. Who is more beautiful or sexy, the film seems to be asking, the lovely but self-involved Edie Sedgwick, who sits at the edge of a bed, ice cubes in her glass tinkling, rambling on about her life, or the mostly silent hunk who lies next to her, naked and distracted, throughout the entire film?

The early paintings, as well, prefigure the films' desublimatory logic. The very grace and asceticism of these canvases function as a counterpoint to the mirror they fix on the indulgent, narcissistic, sensational, or disturbing content of our everyday lives. This juxtaposition—between aesthetic taste and restraint, on the one hand, and the logorrhea of media representations of tragedy, sexiness, sexual affairs, and scandals, on the other—drives home the hypocrisy of a society willing to repress anything it deems erotic, invasive, or violent, but unwilling to give up its unquenchable hunger for representations of brutality, sex, and death. Rather than conceal these obsessions behind platitudes, Warhol reveals both their motivations and their allure through the compulsive reduplication of some of the media's most licentious, lustful, violent, or deadly images. As in Warhol's films, the viewer is brought into close, though relatively safe, proximity with the objects of his or her desires and fears, and subsequently with the basest instincts of violence and death, sex and pleasure that both tempt and frighten us the most.[20] Just as one could become sexually aroused by watching one of Warhol's films, one could easily become repulsed by the sight of one of his bloody crash victims, only to be pulled back from the brink of disgust or nausea by the work's inherent elegance and austerity.

Ultimately, Warhol's greatest *political* legacy was his uncanny ability to transport his various audiences to the precipitous margins of the forbidden and the repressed. Looking back on the artist's impact on the cultural politics of the 1960s, one could argue that the Factory was more than just ground zero for Warhol's world view; it was, in the end, at the dead center of 1960s desublimatory politics—that magical place where artistic labor and libidinal labor merged in the war against repression and the hatred of sex and sexual difference. As Stephen Koch observes:

> It [is possible to] put a new light on the place's libertarian style, the theatrically decadent sex, the silver-covered walls, the helium-filled silver pillows floating, the angelic voice of Callas soaring on and on forever while the inhabitants sailed on amphetamine. The Factory

begins to seem the Great Good place for children of an ideology dominated by petit bourgeois sexual repression, a hypocritical *contempus mundi,* and a preoccupation with the miracles of grace. The Factory was a region of resolution for those dilemmas, another world.[21]

Despite his frivolous side, despite his reactionary friends, despite his ambivalent relationship to politics, Warhol left a valuable social legacy as influential as that of many political figures. In his public persona and much-quoted aphorisms, in his diaries and philosophy, and—most important—in his extraordinary early paintings and films, Warhol tried to resolve the seemingly unresolvable gap between the potent darkness of our desires and the false light of bourgeois respectability. He granted many an artist, writer, choreographer, and filmmaker the permission to celebrate the power of sexuality and desire. Even more remarkably, he granted many a young man and woman—fearful of a sexuality deemed dirty or aberrant by the dominant culture—the permission to come out. In this context, even Warhol's most refined aesthetic gestures had the potential to make a difference. Only in Andy's world would the spectacle of a leather-clad hustler receiving a blow job read as something that was both understandable and boring.

Notes

1. Andy Warhol, as quoted in Richard A. Ogar, "Warhol Mind Warp," *The Berkeley Barb,* 1–7 September 1968, n.p.

2. Andy Warhol, *THE Philosophy of Andy Warhol (From A to B and Back Again)* (New York: Harcourt Brace & Company, 1975), 92.

3. For a discussion of Warhol's politics and the political reception of the artist by critics, left and right, see Benjamin H. D. Buchloh, "The Andy Warhol Line," in *The Work of Andy Warhol,* "Discussions in Contemporary Culture" series, ed. Gary Garrels, no. 3 (Seattle: Bay Press, 1989), 52–69.

4. Ibid., 55.

5. Foster argues that the relentless repetition of these shocking images appropriated from the media, coupled with various formal devices that create visual and sensory dislocations—the slipping and streaking, blanching and blanking of the silkscreen process favored by Warhol, for example—results in a repetitive, optically disorienting "popping" of the image. In Foster's visual equation, "the first order of shock" is contained in the repetition of a graphic image of death or disaster; the second occurs at the level of technique, where a visceral point of trauma—a flickering tear or break in the image's illusion—further dislocates the viewer's experience of the real. "In these early images," Foster concludes, "we see what it looks like to dream in the age of television, *Life,* and *Time*—or rather what it looks like to nightmare as shock victims who prepare for disasters that have already come." For the complete argument, see Hal Foster, *The Return of the Real* (Cambridge: MIT Press, 1996), 127–36.

6. Thomas Crow, "Saturday Disasters: Trace and Reference in Early Warhol," in *Modern Art in the Common Culture* (New Haven: Yale University Press, 1996), 63.

7. Ibid., 49.

8. For more on Warhol's realignment of the experience of painting, see Charles F. Stuckey, "Warhol in Context," in *The Work of Andy Warhol,* ed. Garrels, 8–11.

9. Ivan Karp, paraphrasing Warhol in Patrick S. Smith, ed., *Warhol: Conversations about the Artist* (Ann Arbor: UMI Research Press, 1988), 357.

10. For more on Warhol's evolution as a filmmaker, see John G. Hanhardt, "The Films of Andy Warhol: A Cultural Context," in *The Films of Andy Warhol* (New York: Whitney Museum of American Art, 1988), 7–13.

11. Ibid., 10.

12. In this way, Warhol is much like his aesthetic predecessor, Marcel Duchamp. Annette Michelson has compared Duchamp's tendency to disrupt the channels of communication in his work—from the shifting from French to English pronunciations for the same word to the use of confusing homonyms—to a kind of aesthetic autism that results in the breakdown of any fixed, culturally assigned meaning. Duchamp's "autism" underscores the fragility and privation of language itself, reminding us that the words and images are always marking the absence of the things they represent. Thus for him, the act of speaking, writing, drawing, photographing, or painting was condemned to fail, for representation could not result in "truth," but rather in a distant approximation of reality shaped by the biases and beliefs of the author and of society at large. But if Duchamp undermined the role of language in the bourgeois social order by engaging the viewer with inscrutable mind games—*The Large Glass* (1915–23), for example, spoofs the conventions of courtship and marriage by transporting us to the mystical, purely conceptual realm of a mechanical bride and her ejaculating bachelors—Warhol was interested in far baser, visceral disruptions of the viewer's expectations. For more on Duchamp's "autism," see Annette Michelson, "Anemic Cinema: Reflections on an Emblematic Work," *Artforum* 12 (October 1973); reprinted in Amy Baker Sandback, ed., *Looking Critically: 21 Years of Artforum Magazine* (Ann Arbor: UMI Research Press, 1984), 143–48.

13. Rather than regarding this repression of our sexual drives as dangerous, Freudian psychoanalysis to an extent invested in its virtues. Yet even Freud himself openly wondered whether the very neurosis he sought to cure by psychoanalysis might be due to this repression. Freud contemplates the dangers of sexual sublimation in "'Civilized' Sexual Morality and Modern Nervous Illness," in *The Complete Psychological Works of Sigmund Freud*, vol. 7, ed. James Strachey (London: Hogarth, 1959), 191.

14. For a discussion of Marcuse's relationship to radical art and culture in the 1960s, see Maurice Berger, *Labyrinths: Robert Morris, Minimalism, and the 1960s* (New York: Harper & Row, 1989), 61–62, 74–75.

15. Stephen Koch, *Stargazer: Andy Warhol's World and His Films* (New York: Praeger, 1973), 5.

16. Ibid., 3.

17. Warhol, *THE Philosophy of Andy Warhol*, 45.

18. Koch, *Stargazer*, 73.

19. Ibid., 74.

20. In this context, certain works by Warhol that might appear to be without social content or even frivolous can be seen to further the artist's transgressive goals. His installation of helium-filled silver pillows, *Silver Clouds* (1966), for example, challenged the repressive, rigid order of the gallery space by allowing viewers to directly interact and play with sensual objects. As if to underscore the work's psychosexual edge, Warhol's first idea for this installation called for inflatable vinyl light bulbs, in effect, creating a field of floating phalluses.

21. Koch, *Stargazer*, 11.

Mirror, Shadow, Figment: Andy Warhol's *America*

TREVOR FAIRBROTHER
Deputy Director of Art / Jon and Mary Shirley Curator of Modern Art, Seattle Art Museum

FIGURE 14: *America*, cover

Social observation and critique were fundamental to Pop art, a new mode of figuration in the early 1960s that was connected to consumerism and the popular culture of the period. Early mainstream responses generally argued that Pop did not look like art and that its artists were too business-motivated, too upbeat and ironic to be respected. This shocked reaction was enhanced by the gibes of the long-suffering Abstract Expressionist regime: senior critic Harold Rosenberg stated that Pop was "Advertising art which advertises itself as art that hates advertising."[1] As the ultimate New York Pop artist, Andy Warhol contributed to the movement's social observations. He made austere photo-based paintings of mass-produced food products, car crashes, rock stars, electric chairs, screen idols, race riots, and the widowed Jackie Kennedy, while foppishly withholding coherent opinions about them. Unlike his peers, Warhol created a celebrity persona that was an extension of his art. His public image combined the art antics of Salvador Dali and the vacuous affectations of Marilyn Monroe. Wearing a wig and donning a trendy masquerade, Warhol mounted a circus with a bohemian entourage and a studio that was the projected epicenter of freedom, fun, and success. Not surprisingly, mainstream culture took the artist for a fool and his art for a gimmick. His social critique was either unseen or not believed, but everyone learned his name.

Media commentators were partly responsible for Warhol's legendary silence, for they approached his art with insulting frivolity. But he knew that he could get more attention if, as the maker of supposedly dumb art, he acted dumb. Thus tagged, he used celebrity and artist-provocateur strategies to stay in the spotlight for the rest of his life. An unusually verbose interview of 1967 gives some context for Warhol's detachment and diffidence:

> I don't talk very much or say very much in interviews. I'm really not saying anything now. If you want to know all about Andy Warhol just look at the surface of my paintings and films and me, and there I am. There's nothing behind it…. I always had this philosophy of 'It really doesn't matter.' It's an Eastern philosophy…. I'm not trying to educate people to see things or feel things in my paintings. There's no form of education in them at all.[2]

Blankness and nothingness became important metaphors in Warhol's art, possibly suggesting existential emptiness, meditative retreat, withdrawal from worldly cares, or a mirrorlike void for each viewer's reflections. Some of his classic Pop pictures are diptychs in which one panel is a monochrome field without imagery—a "blank." In 1967 Warhol's rock group, the Velvet Underground, sang, "I'll be your mirror, reflect what you are, in case you don't know." In *The Shadow*, a self-portrait of 1981, the artist's deathly face occupies the far right of the picture, while the shadow of his profile looms eerily on the wall behind. (*The Shadow* is one of the ten American sacred monsters in Warhol's *Myths* portfolio; the others are *The Star*, *The Witch*, *Dracula*, *Mammy*, *Santa Claus*, *Mickey Mouse*, *Superman*, *Howdy Doody*, and *Uncle Sam*.) Warhol's *America*, a book published in 1985, embellished his conflicted yearning to be both nobody and somebody special. The text accompanying photographs of upper-crust tombstones in Lenox, Massachusetts, states: "I always thought I'd like my tombstone to be blank. No epitaph, and no name. Well, actually, I'd like it to say 'figment.'"[3] A year later, Warhol got close to his "figment" ideal in his "Camouflage" self-portrait series, in which he presented himself as a harrowing, disembodied head staring from a veil of camouflage: there and not there, familiar and unknowable—an inspiring, cautionary devotional image (figure 21).

Since Warhol's death in 1987, numerous monographs and biographies have fleshed out the personal story of this lovable-hateable "blank." We now have a fuller understanding of the context in which Warhol's detachment evolved. His immigrant parents were Catholics, as was he; art school offered the opportunity to transcend his blue-collar background; a commercial job in New York was an escape from Pittsburgh and the moment to abbreviate his name, Andrew Warhola. A nose job provided some kind of hope; a wig solved his hair problem and then became a signature accessory. The quest for a gay partner in a homophobic society was another kind of hope; and his willful, hard-earned move from illustrating shoe advertisements to an independent career as a painter and Pop art celebrity was a triumph—but not the happily-ever-after life he might have been imagining. He went on to make famous underground movies but never won Hollywood's interest, survived a near-fatal shooting in 1968, started a successful magazine, launched a career as a portrait painter, and on and on and on.

In 1983, after seeing the enormous archive of photographs that Warhol had taken and never published, New York editor Craig Nelson suggested that the artist consider doing "a photo-and-essay book" devoted to America. Nelson had recently brought out a new edition of *POPism: The Warhol '60s*, first published in 1980.[4] Thus, like many of his other projects, Warhol inspired rather than conceived *America*. Although it may seem surprising that the tortured "figment" from New York would take on America, especially in light of his attachment to the ephemeral and his penchant for avoiding deep statements, Warhol's pictures and texts confirm that he was nonetheless an astute social observer. The book compellingly meshes his personal anxieties with some of his perceptions of the nation's malaise in the 1980s.

America has the same kind of freewheeling structure that characterizes Warhol's other publications.[5] One's first impression is that the approach is too casual for its vast topic. But the book quickly proves to be a tough and disturbing mixture of optimistic apple-pie patriotism and bleak social reportage. After an affirming epigraph— "America really is The Beautiful" —the book becomes an invitation to consider why things in the United States are not as good as they could be in the 1980s. Warhol's blatant careerism in the previous decade lost him many supporters. Larry Frascella, who reviewed *America* for the photography journal *Aperture*, seemed surprised that he liked the book as much as he did: "It's a merciless hall of mirrors, reflecting an entirely valid view of living in the U.S.A.... Warhol's worldview has never stayed in focus as well as it does here.... Potent one day, disposable the next, Warhol's camera eye delivers a cynical but deadly accurate picture of our times."[6] The decision to put the Statue of Liberty on the cover of *America* was obvious yet subversively inspired (figure 14). The grainy black image printed on silver paper instantly connects the book to Warhol's paintings of the 1960s (in fact, it reprises them, for he produced some multiple-image canvases of the statue in 1963). The Statue of Liberty has associations with Warhol's New York career, his immigrant heritage, and his populist instincts. But *America* creates a critical edge by showing the national monument encased in scaffolding. Is this a suggestion that America is a continually evolving, visionary social experiment, or is it a hint that the country is tired and in need of a make-over?

about the big problem: Trust Fund Syndrome. If you inherit so much money that you never have to work, what do you do? There's only so much TV and vacations and lunching around that any-one can take, so if you get the money and then get the syndrome, you wander around, thinking to yourself: Who am I? What should I do? But having "old money"—that's great.

FIGURE 15: *America*, pp. 206–207

Without copping out, Warhol's pointed interweaving of pictures and texts seems to answer yes to both questions. The criticisms of the United States are so sharp that one doubts the sincerity of the most corny and patriotic parts of the book. The reader is left with the sense that Warhol *wants* to believe in the country's greatness, but this is the best he could do, given the circumstances of the early 1980s.

The first page of text begins: "Everybody has their own America, and then they have the pieces of a fantasy America that they think is out there but they can't see." Warhol argues that we all live in two Americas: the real one and a dream one that each of us has custom-made from our favorite "scenes in movies and music and lines from books." *America* proceeds as an elliptical, deceptively chitchatty rumina-tion on the forces that control the real and the dream versions of the country. As much as Warhol wants to believe in the national dreams of his youth (Depression-era democratic social reform), he admits that change is now happening too quickly, that an alarming number of people are homeless, and that many more have had their minds messed up by the entertainment industry.

> [TV] has really taken a lot of the mystery out of the parts of America that you don't get to much, or maybe never will.... The people on the farms can turn on TV and see the clubs in New York, and the people in the clubs in New York can turn on the TVs and watch the grass growing out in the country. Everybody can see how the other half lives.

Hindsight shows that Warhol's vision of live TV coverage of almost anything is now fulfilled by the Internet, but, as he was quick to point out in 1985, film was the first medium to control public desire. "It's the movies that have really been running things in America ever since they were invented. They show you what to do, how to do it, when to do it, how to feel about it, and to *look* how you feel about it." Warhol is both exhilarated and melancholic about living in the fast-paced present with no time for serious reflection:

> There's no country in the world that loves 'right now' like America does.... We don't have time to remember the past, and we don't have the energy to imagine the future; we're so busy, we can only think: Now!... It gets to the point where we can barely remember what came out before we're rushed to the next, newer sensation.... There's more media every day: cable TV, satellite TV, new magazines starting up every minute. And with more media, they need more celebrities and more news to have something to talk about.

By 1985 Warhol was not quite as enthusiastic about celebrity as his public image suggested. He seemed ready to admit that the media creates a big mirage in which all the players project the phony impression that everything is "just great." These media people are "half-people" rather than real people: "With people only in their public personalities, and with the media only in the Now, we never get the full story about anything. Our role models, the people American children think of as heroes, are all these half-people." Warhol admits that meeting real celebrities is exciting because they give us the feeling "of being special, of being with someone who's different and better and famous." But ultimately he finds TV-mediated culture poisonous compared with the star system of Hollywood's Golden Age:

> Now we've got all these people in their twenties and thirties with a part of them deep down inside looking for the real life they learned on TV. They think their own childhood and their own families are failures, because they don't measure up to TV children and families.... People with television dreams are really disappointed with everything in their lives.

In one of the book's many ironic asides, he offers a self-help tip for this TV-induced misery: pets.

Warhol gives magazines the same hard time that he gives TV and movies. He equates his country with its pulp journalism by naming five chapters after popular magazines: *People*, *Physique Pictorial*, *National Geographic*, *Vogue*, and *Life*. Even though a publisher himself, he indicates that this business is insidious, cynical, and more interested in fads than in truths. "Just look at all the big American magazines, where the exciting things are only the newest things." Although magazines at that time were writing about a new American conservatism, Warhol counters: "You go to the clubs and see kids doing and wearing crazier things than ever before. So I wonder if all these sweeping trends that every magazine wants to be the first to plug into are sort of fake, that it's all just something you read about." He certainly managed to annoy the real *People* magazine, whose review of *America* stated: "Warhol trots out tedious pictures of megacelebrities and the freaky types who are denizens of his New York netherworld. They are certainly American. They are certainly not America, particularly in the inhumane way Warhol portrays people."[7] Warhol never acknowledges in the book that he has participated in these processes since the 1960s, developing art businesses that use his own constructed glamour to attract collaborators, staffers, clients, and buyers. One spread, however, nods to artifice, style, and social ambition: the photographs show people

FIGURE 16: *America*, pp. 194–95

wearing wigs (including four Warhol look-alike contest-ants) and a woman in a clear mesh dress who might as well be naked (figure 15). When *America* hit the book-stores, Warhol was working on his own television show and wondering whether to explore Coleco's offer "to do an Andy Warhol line of clothing."[8]

The good news Warhol imparts in *America* feels rather generic. His text observes that there are now so many products to choose from. After showing a tightly packed display of candies and listing dozens of beverage choices, he praises the democratic principle involved: "You see a billboard for Tab and think: Nancy Reagan drinks Tab, Gloria Vanderbilt drinks Tab…and, just think, you can drink Tab too. Tab is Tab and no matter how rich you are, you can't get a better one than the one the homeless woman on the corner is drinking."

Warhol is especially pleased about America's new interest in physical fitness (which is a cue for a visual digression into a photo section dominated by male body-builders, strippers, and wrestlers). Although he thinks that the tourist industry has made Washington, D.C., seem like "just…another kind of Disney World," he insists that "the big, great, incredible American things" like the Declaration of Independence or the Vietnam Memorial can trigger national pride and provide an experience of

Now it seems like nobody has big hopes for the future. We all seem to think that it's going to be just like it is now, only worse. But who's to say that this idea is any more realistic than dreaming about robots?

FIGURE 17: *America*, pp. 186–87

"magic." Warhol admits that his visits to the West and even to the suburbs make him think "this is the real America." But the romanticism of his initial response gives way to the realization that every place in the country has the same proportion of "nutty" and "crazy" people. He then declares, "Nobody in America has an ordinary life. And the real America is wherever you happen to be in the U.S. when you start wondering about the question."

The massive oceanic temperament of the country eventually gets its due when Warhol introduces the romantic notion of mood:

> America always begins with Moods…. But the trouble with moods is that they're always changing, sometimes really fast. And when that happens, the movies change, the babies change, the votes change, the decisions change, and America flip-flops onto something totally new. This makes all the other countries in the world not know what to think—one year we're yelling about human rights, and the next we're mining some foreign country's harbors. We're moody, and the moods swing, and we'll change our moods completely about everything.

But just when he seems comfortable with national changeableness, Warhol throws in this rather creepy note: "That's why the American government and the American media are so great. The President, the newsmagazines, television—they only want to capture America's mood at the moment, reflect it back, and tell anyone who's not in the same mood to get over it and start feeling American like everyone else." Intended or not, this has the same euphemistic tone as "Just Say No"—the slogan of First Lady Nancy Reagan's 1983 antidrug campaign.

It is important to remember that *America* was a commercial product with a business strategy: Warhol's name plus nationalistic sentiment equal best-seller. That was the framework in which Warhol had the nerve to be caustic. The text adjacent to his close-up photograph of a grinning, waving Howdy Doody puppet states: "I keep waiting—like everybody else is—for a really great person in political life. I watch TV on Sunday mornings to look for politicians that I could like, but all I see are guys scared to lose their jobs just trying to talk for thirty minutes without getting fired." A spread titled "Editorial" includes

the comment: "This country is so rich. And I think I see more homeless people on the street every month. How can we let this keep happening?" (figure 16).

In the book's opening section, Warhol states:

> I think that the most important thing the government should do for people with no place to live is build huge modern bath-houses where you could go and have both a shower and a washer-dryer to get you and your clothes clean at the same time. And there'd be a time limit, or otherwise people would start living in there.

It was his cockeyed but telling belief that people don't really need money for food if they have style: "I see the same chic poor people night after night at the parties in New York. All you've got to do is look right and anybody will be happy to feed you, no questions asked."

Warhol's contradictory statements about money betray unease, and some of his thoughts are just plain baffling. But this might have been his way to acknowledge that American democracy engenders a plutocracy and an underclass. At the beginning of the book he says, "I wish somebody great would come along in public life and make it respectable to be poor again." And near the end he quips, "Getting rich isn't as much fun as it used to be.... If you inherit so much money that you never have to work, what do you do?... If you get the money and then get the [trust fund] syndrome, you wander around, thinking to yourself: Who am I? What should I do? But having 'old money'—that's great."

Warhol's tarnished faith lies in the power of old-fashioned progressivism.

> One thing I miss is the time when America had big dreams about the future.... You'd go to the World's Fair and see a movie where the audience gets to vote on every step of the plot, and monorails that were completely silent but moved really fast.... Now it seems like nobody has big hopes for the future. We all seem to think that it's going to be just like it is now, only worse. But who's to say that this idea is any more realistic than dreaming about robots? [figure 17]

He is both confused and frustrated by the fact that "a lot of good ideas just seem to fade away." And this, in my opinion, is an indication that the book is ultimately less "about" the nation than it is tied to the author's attempts to rationalize his own attitudes and practices in relation to those of his country. It is a covert self-portrait born at a time of personal doubt—middle age, professional anxiety about his standing in relation to the newest generation of art stars, lousy romances, poor health, and AIDS paranoia.[9] Warhol probably hoped that his look at America would make him feel better about his own problems.

America encapsulates the uncanny eye and mind of an exceptional, witty, quirky, and embattled person. Pretty things pop up along the way, but there is a steady rhythm of photos that rip the veneer right off. Warhol leaves us plenty of situations to consider: a tired, dignified older man protests on the sidewalk with a placard that reads "Sotheby Cheats"; young, handsome, and hobolike, the graffiti artist Jean-Michel Basquiat lands an exhibition at the Mary Boone Gallery (figure 18); two actors from the TV show *Dynasty*, Linda Evans and John Forsythe, have the appearance of power and privilege; President Reagan looks like the other aging Hollywood stars elsewhere in the book; well-dressed Yuppie children roll around on a carpet; a Gay Pride march passes by; people vamp, make art, laugh, put on makeup, dance, hold up babies, sunbathe, play sports, take photographs, show off their pets, lift weights, and blow out birthday-cake candles.

FIGURE 18: *America*, pp. 48–49

Notes

I would like to thank Jonathan Binstock, Susan Mulcahy, Craig Nelson, Tara Reddy, and Barbara Richer, and I am especially grateful to John Kirk for his fast editorial comments.

1. Ian Chilvers, ed., *The Concise Oxford Dictionary of Art and Artists* (Oxford: Oxford University Press, 1996), 416.

2. Gretchen Berg, "Nothing to Lose: Interview with Andy Warhol," *Cahiers du Cinema* (English edition) 10 (1967): 40.

3. Andy Warhol, *America* (New York: Harper & Row, 1985), 129. Unless otherwise indicated, the Warhol quotations in this essay are from *America*.

4. Craig Nelson kindly outlined his involvement with *America* for me. Barbara Richer, who designed the book, recently confirmed that Warhol and Nelson culled the photographs and delivered them to her loosely grouped into thematic sections. Richer designed the final layout and used large "rough" type for section headings. She remembers the project with fondness: "Warhol loved my type. He was shy. It was very free and a lot of fun."

5. Warhol's book projects date back to the 1950s. Some of his illustrations in *A Is an Alphabet* (1953) were based on photographs in *Life* magazine. In *THE Philosophy of Andy Warhol* (1975), he wrote on a signature list of topics— sex, work, food, success, beauty, money, fame, love, and America. The photographs and text of *Andy Warhol's Exposures* (1979) were devoted to celebrities, and *POPism: The Warhol '60s* (1980) was a retelling of his heyday.

6. Larry Frascella, "Andy Warhol's *America*," *Aperture* 103 (Summer 1986): 12, 14.

7. R. N., "*America* by Andy Warhol," *People*, 18 November 1985, 18.

8. Pat Hackett, ed., *The Andy Warhol Diaries* (New York: Warner Books, 1989), 684: "The Coleco Cabbage Patch guy came by. And he didn't like the paintings of Cabbage Patch dolls I did, but he's paying anyway.... He proposed that he do an Andy Warhol line of clothing with me and that we could both make lots of money. He said that his computer had told him that I was the most famous living artist."

9. Warhol's biographers devote scant attention to *America*. Victor Bokris, in a chapter of his book titled "Everything Is Boring," suggests that Warhol was "disappointed" with *America* and "lackadaisical" about the publicity tour. He also quotes the critic Gary Indiana, a lapsed Warhol fan: "The inanities had ceased to charm, having reached a brutal apotheosis with the picture book, *America*.... Lately, Andy had resorted to flirtation." See Victor Bokris, *Warhol* (London: Frederick Muller, 1989), 478.

disguise
death and disaster
politics
cover stories
advertising
celebrity
symbolism

DISGUISE

"When I did my self-portrait, I left all the pimples out because you always should. Pimples are a temporary condition and they don't have anything to do with what you really look like. Always omit the blemishes—they're not part of the good picture you want."

—from *THE Philosophy of Andy Warhol*, 62

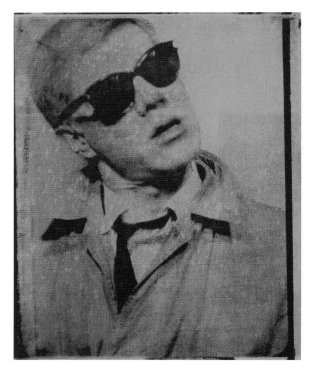

FIGURE 19: **SELF-PORTRAIT**, 1964. Synthetic polymer paint and silkscreen ink on canvas, 20 x 16" (50.8 x 40.6 cm). Courtesy The Brant Foundation, Greenwich, Conn.

FIGURE 20: **CAMOUFLAGE**, 1986. Synthetic polymer paint and silkscreen ink on canvas, 80 x 80" (203.2 x 203.2 cm). Courtesy Gagosian Gallery, New York

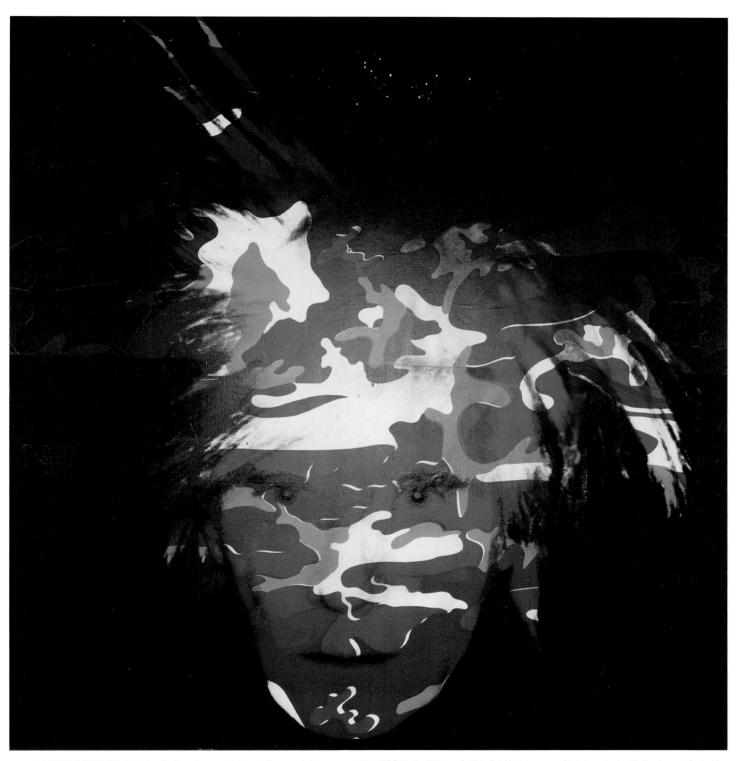

FIGURE 21: **SELF-PORTRAIT**, 1986. Synthetic polymer paint and silkscreen ink on canvas, 82 x 82" (208.3 x 208.3 cm). Philadelphia Museum of Art. Acquired with funds contributed by the Committee on Twentieth Century Art and as a partial gift of The Andy Warhol Foundation for the Visual Arts, Inc.

DEATH AND DISASTER

" **I believe in [death]. Did you see the** *Enquirer* **this week? It had 'The Wreck that Made Cops Cry'—a head cut in half, the arms and hands just lying there. It's sick, but I'm sure it happens all the time.**"

—quoted by G. R. Swenson, "What is Pop Art?," 60

FIGURE 22: **MOST WANTED MEN NO. 1, JOHN M.**, 1964. Synthetic polymer paint and silkscreen ink on canvas, two canvases, each 49 x 37 3/4" (124.5 x 95.9 cm). The Herbert F. Johnson Museum of Art, Cornell University. Purchase Funds from the National Endowment for the Arts and individual donors

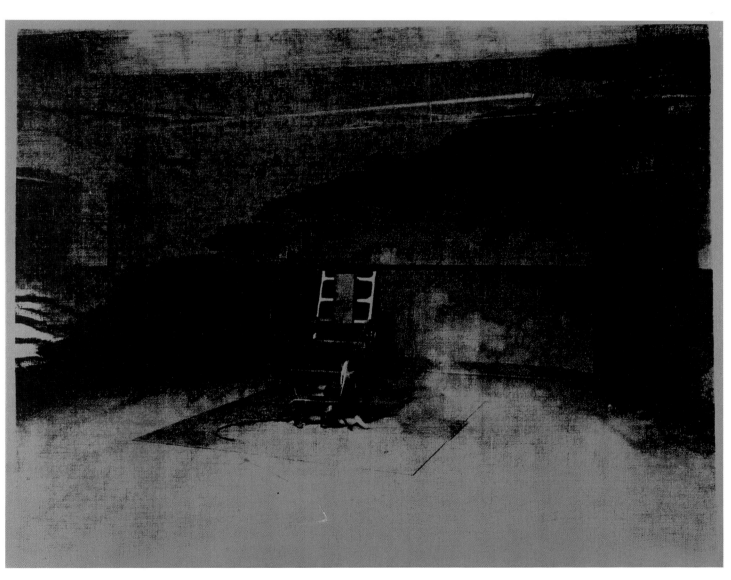

FIGURE 23: **LITTLE ELECTRIC CHAIR**, 1965. Synthetic polymer paint and silkscreen ink on canvas, 22 x 28" (55.9 x 71.1 cm). Courtesy The Brant Foundation, Greenwich, Conn.

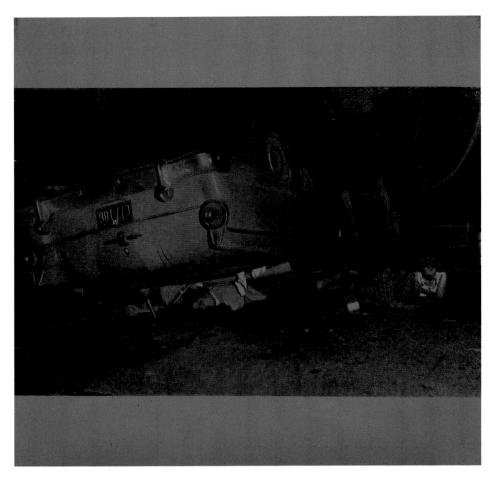

FIGURE 24: **5 DEATHS IN YELLOW**, 1963. Synthetic polymer paint and silkscreen ink on canvas, 30 1/8 x 30 1/8" (76.5 x 76.5 cm). Sonnabend Collection

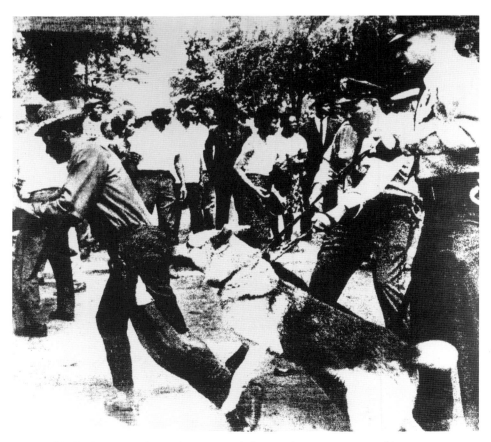

FIGURE 25: **RACE RIOT**, 1964. Synthetic polymer paint and silkscreen ink on canvas, 30 x 32 7/8" (76.2 x 83.5 cm). Museum of Art, Rhode Island School of Design, Providence. Albert Pilavin Memorial Collection of Twentieth Century American Art

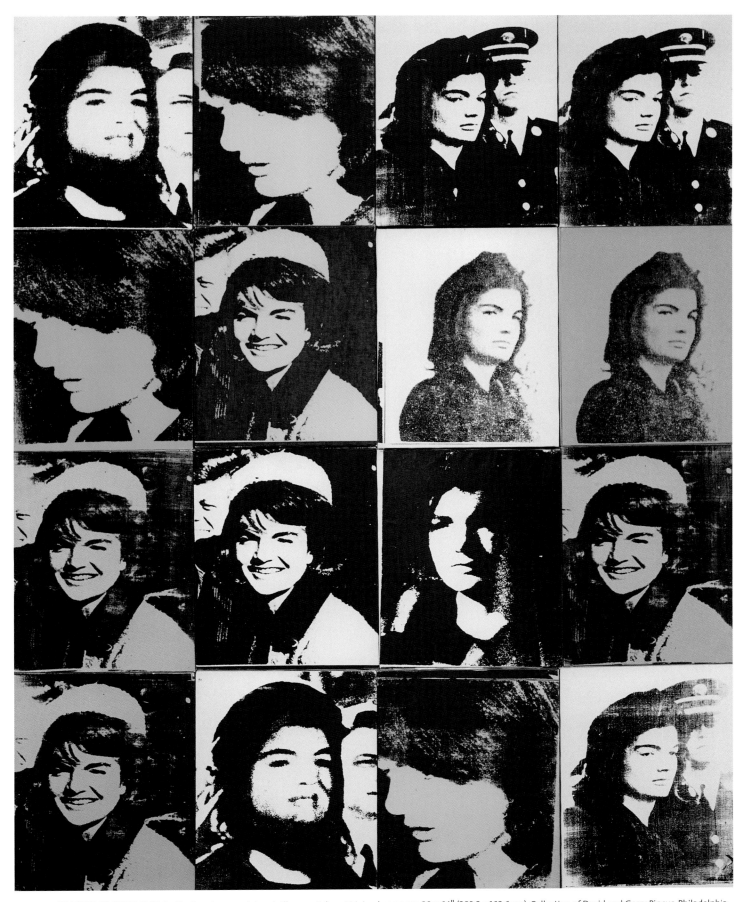

FIGURE 26: **SIXTEEN JACKIES**, 1964. Synthetic polymer paint and silkscreen ink on 16 joined canvases, 80 x 64" (203.2 x 162.6 cm). Collection of David and Gerry Pincus, Philadelphia

POLITICS

"You mean, the Shah might not be the Shah anymore?
You mean, we might not get paid? Politics are so abstract."

—quoted by Bob Colacello, *Andy Warhol: Camouflage* (Gagosian Gallery, 1998), 7

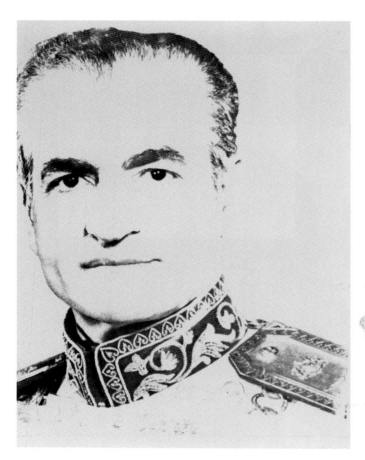

FIGURE 27: **SHAH OF IRAN**, ca. 1978. Unique screenprint on Curtis rag paper, 45 x 35" (114.3 x 88.9 cm). The Andy Warhol Museum, Pittsburgh. Founding Collection, Contribution The Andy Warhol Foundation for the Visual Arts, Inc.

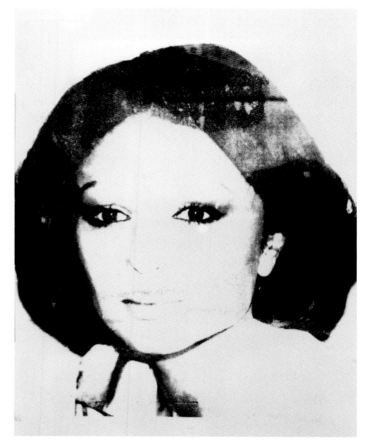

FIGURE 28: **(FARAH) DIBAH PAHLAVI**, ca. 1978. Unique screenprint on Curtis rag paper, 45 x 35" (114.3 x 88.9 cm). The Andy Warhol Museum, Pittsburgh. Founding Collection, Contribution The Andy Warhol Foundation for the Visual Arts, Inc.

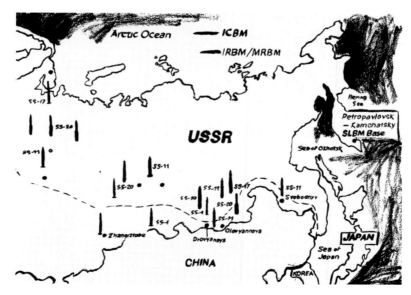

FIGURE 29: **MAP OF EASTERN U.S.S.R. MISSILE BASES**, ca. 1985–86. Synthetic polymer paint and silkscreen ink on canvas, 72 x 80" (182.9 x 203.2 cm). The Andy Warhol Foundation for the Visual Arts, Inc., New York

FIGURE 30: **LENIN**, 1986. Synthetic polymer paint and silkscreen ink on canvas, 22 x 16" (55.9 x 40.6 cm). Courtesy Gagosian Gallery, New York

FIGURE 31: **UNTITLED (HUEY LONG)**, 1948–49. Pen and ink on paper, 29 1/16 x 23 1/16" (73.8 x 58.6 cm). Carnegie Museum of Art, Pittsburgh. Gift of Russel G. Twiggs, 1968

FIGURE 32: **FIGURES HOLDING PICKET SIGNS**, 1950s. Ink on Strathmore paper, 13 1/4 x 11 3/8" (33.7 x 28.9 cm). The Andy Warhol Museum, Pittsburgh. Founding Collection, Contribution The Andy Warhol Foundation for the Visual Arts, Inc.

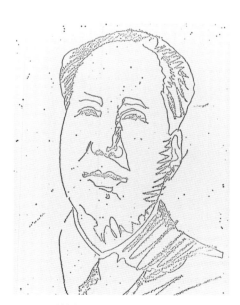

FIGURE 33: **MAO**, 1973. Published for the portfolio *The New York Collection for Stockholm*, edition 27/300, Xerox print on typewriter paper, 11 x 8 1/2" (27.9 x 21.6 cm). Brooklyn Museum of Art. Gift of Theodore Kheel, 76.201.29

FIGURE 34: **MAO**, 1973. Published for the portfolio *The New York Collection for Stockholm*, edition 100/300, Xerox print on typewriter paper, 11 x 8 1/2" (27.9 x 21.6 cm). Brooklyn Museum of Art. Gift of Theodore Kheel, 76.202.29

FIGURE 35: **MAO**, 1973. Published for the portfolio *The New York Collection for Stockholm*, edition 265/300, Xerox print on typewriter paper, 11 x 8 1/2" (27.9 x 21.6 cm). Philadelphia Museum of Art. Gift of Robert Rauschenberg, Inc.

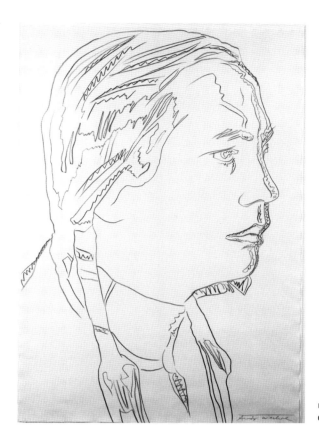

FIGURE 36: **THE AMERICAN INDIAN (RUSSELL MEANS)**, 1976.
Graphite on paper, 40 x 27" (101.6 x 68.6 cm). Collection of Jane Holzer, New York

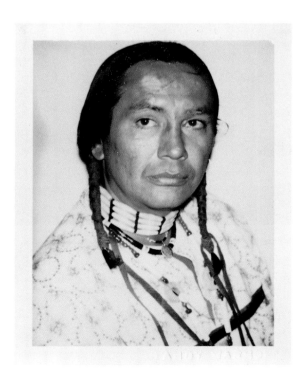

FIGURE 37: **THE AMERICAN INDIAN (RUSSELL MEANS)**, 1976.
Polaroid photograph, 4 1/4 x 3 3/8" (10.8 x 8.6 cm). The Andy Warhol
Foundation for the Visual Arts, Inc., New York

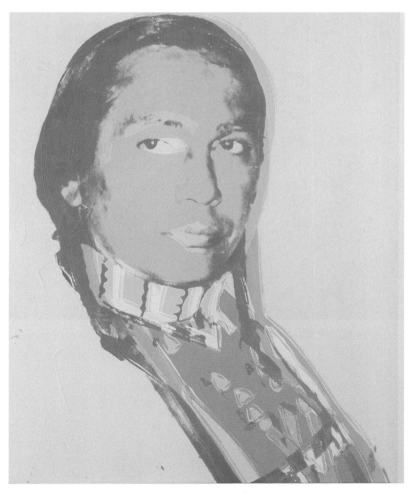

FIGURE 38: **THE AMERICAN INDIAN (RUSSELL MEANS)**, 1976. Synthetic polymer paint and
silkscreen ink on canvas, 50 x 42" (127 x 106.7 cm). The Andy Warhol Museum, Pittsburgh. Founding
Collection, Contribution The Andy Warhol Foundation for the Visual Arts, Inc.

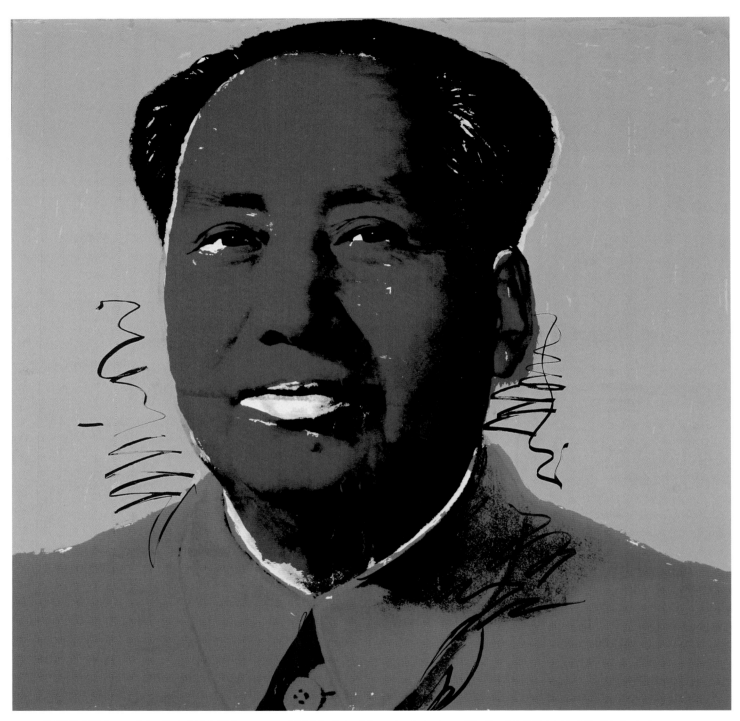

FIGURE 39: **MAO**, 1972. Screenprint on Beckett High White paper, 36 x 36" (91.4 x 91.4 cm). Pennsylvania Academy of the Fine Arts, Philadelphia. Gift of Marian Locks

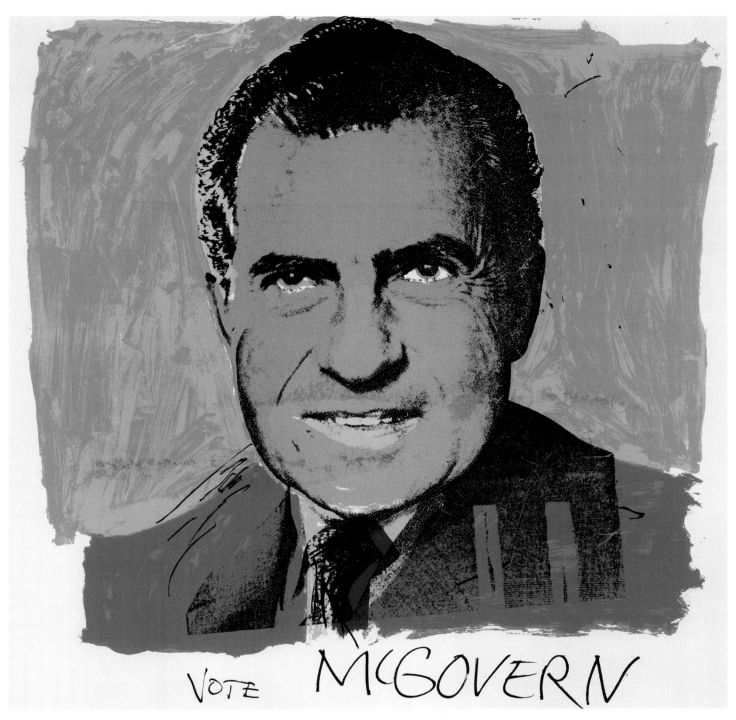

FIGURE 40: **VOTE McGOVERN**, 1972. 16-color silkscreen on Arches 88 paper, 42 x 42" (106.7 x 106.7 cm). National Gallery of Art, Washington, D.C. Gift of Benjamin B. Smith, 1985

COVER STORIES

"I'm confused about who the news belongs to. I always have it in my head that if your name's in the news, then the news should be paying you. Because it's your news and they're taking it and selling it as their product. But then they always say that they're helping you, and that's true too, but still, if people didn't give the news their news, and if everybody kept their news to themselves, the news wouldn't have any news. So I guess you should pay each other. But I haven't figured it out yet."

—from THE Philosophy of Andy Warhol, 76

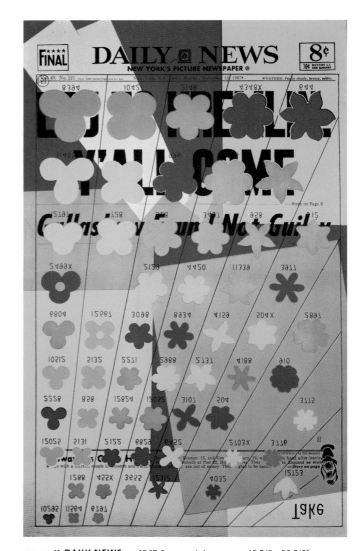

FIGURE 41: **DAILY NEWS**, ca. 1967. Screenprint on paper, 49 7/8 x 29 7/8" (126.7 x 75.9 cm). Courtesy Gagosian Gallery, New York

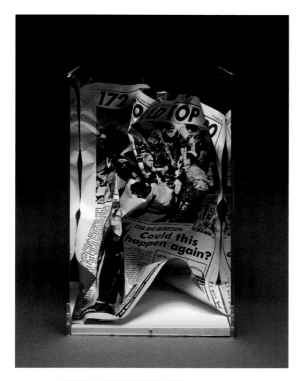

FIGURE 42: **ABSTRACT SCULPTURE**, 1983. Screenprint on crumpled Mylar, 18 x 12 x 9 3/4" (45.7 x 30.5 x 24.8 cm). Collection of Christopher Makos, New York

FIGURE 43: **ABSTRACT SCULPTURE**, ca. 1984. Synthetic polymer paint and silkscreen ink on canvas, 16 x 20" (40.6 x 50.8 cm). The Andy Warhol Foundation for the Visual Arts, Inc., New York

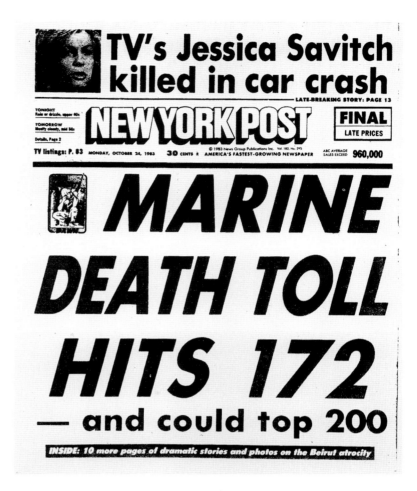

FIGURE 44: **NEW YORK POST FRONT PAGE (SAVITCH/MARINE)**, ca. 1983. Synthetic polymer paint and silkscreen ink on canvas, 24 x 20" (61 x 50.8 cm). The Andy Warhol Foundation for the Visual Arts, Inc., New York

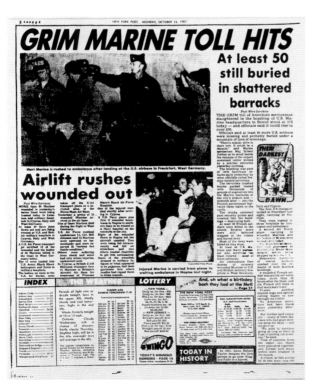

FIGURE 45: **NEW YORK POST FRONT PAGE (GRIM MARINE TOLL)**, ca. 1983. Synthetic polymer paint and silkscreen ink on canvas, 24 x 20" (61 x 50.8 cm). The Andy Warhol Foundation for the Visual Arts, Inc., New York

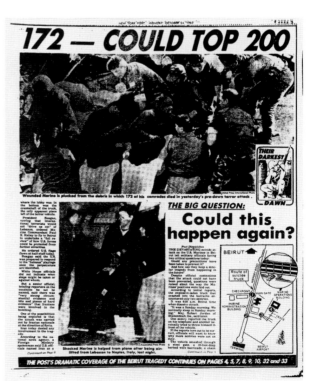

FIGURE 46: **NEW YORK POST FRONT PAGE (172—COULD TOP 200)**, ca. 1983. Synthetic polymer paint and silkscreen ink on canvas, 24 x 20" (61 x 50.8 cm). The Andy Warhol Foundation for the Visual Arts, Inc., New York

ADVERTISING

"I finally got a BMW painted, black with pink roll-on flowers. Maybe they'll read meaning into it. I hope so."

—from *The Andy Warhol Diaries*, 127

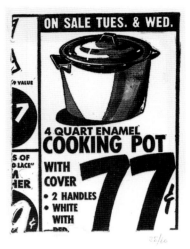

FIGURE 47: **COOKING POT**, 1962. Photoengraving on Rives BFK paper, 10 x 7 1/2" (25.4 x 19 cm). Philadelphia Museum of Art. Purchased with the Print Revolving Fund

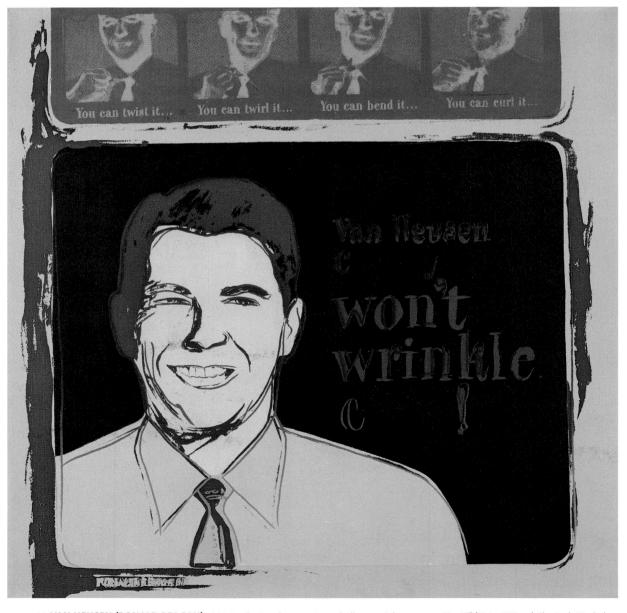

FIGURE 48: **VAN HEUSEN (RONALD REAGAN)**, 1985. Synthetic polymer paint and silkscreen ink on canvas, 22 x 22" (55.9 x 55.9 cm). The Andy Warhol Museum, Pittsburgh. Founding Collection, Contribution The Andy Warhol Foundation for the Visual Arts, Inc.

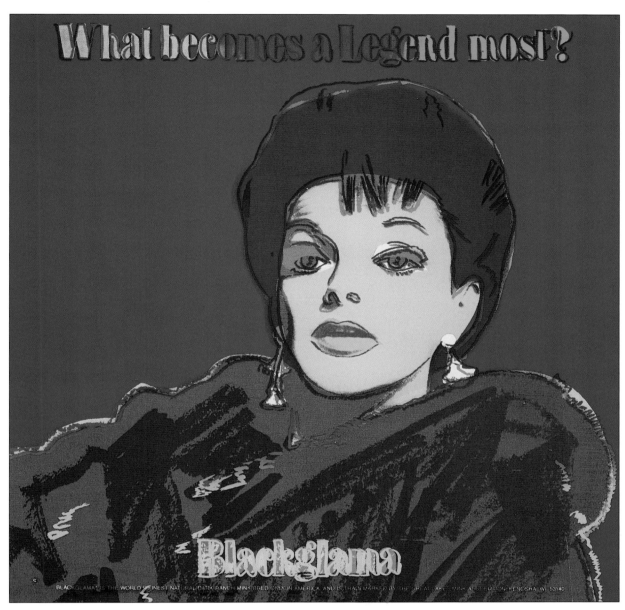

FIGURE 49: **BLACKGLAMA (JUDY GARLAND)**, 1985. Synthetic polymer paint and silkscreen ink on canvas, 22 x 22" (55.9 x 55.9 cm). The Andy Warhol Museum, Pittsburgh. Founding Collection, Contribution The Andy Warhol Foundation for the Visual Arts, Inc.

FIGURE 50: **BEFORE AND AFTER**, 1961. Synthetic polymer paint on canvas, 54 x 69 7/8" (137.2 x 177.5 cm). The Museum of Modern Art, New York. Gift of David Geffen

CELEBRITY

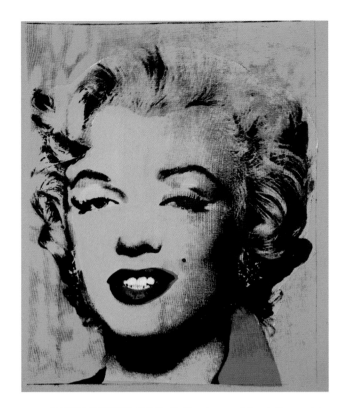

FIGURE 51: **BLUE MARILYN**, 1962. Synthetic polymer paint and silkscreen ink on canvas, 20 x 16" (50.5 x 40.3 cm). The Art Museum, Princeton University. Gift of Alfred H. Barr, Jr., Class of 1922, and Mrs. Barr

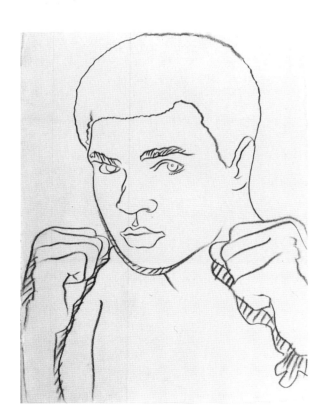

FIGURE 52: **MUHAMMAD ALI**, 1978. Graphite on HMP paper, 31 1/4 x 23 3/4" (79.4 x 60.3 cm). Courtesy The Brant Foundation, Greenwich, Conn.

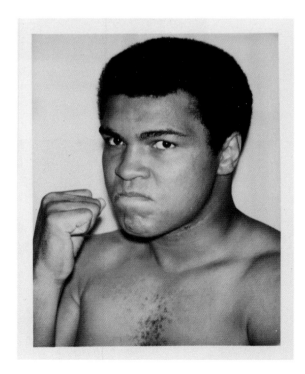

FIGURE 53: **MUHAMMAD ALI**, ca. 1977. Polaroid photograph, 4 1/4 x 3 3/8" (10.8 x 8.6 cm). The Andy Warhol Foundation for the Visual Arts, Inc., New York

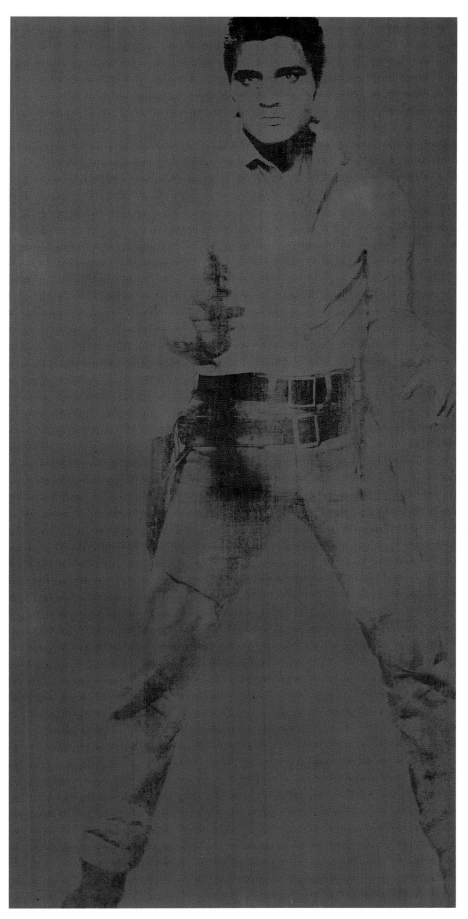

FIGURE 54: **SINGLE ELVIS**, 1963. Synthetic polymer paint and silkscreen ink on canvas, 82 x 40" (208.3 x 101.6 cm). Akron Art Museum. Purchased with the aid of funds from the National Endowment for the Arts and the L. L. Bottsford Estate Fund

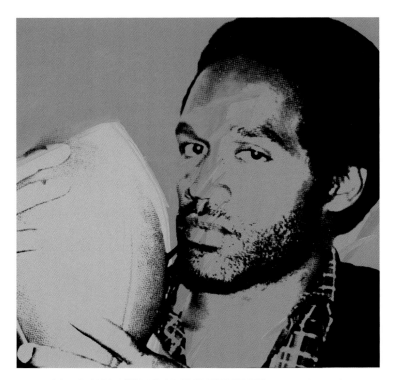

FIGURE 55: **O.J. SIMPSON ("SUITE OF ATHLETES" SERIES)**, 1977. Synthetic polymer paint and silkscreen ink on canvas, 40 x 40" (101.6 x 101.6 cm). The Art Gallery, University of Maryland, College Park

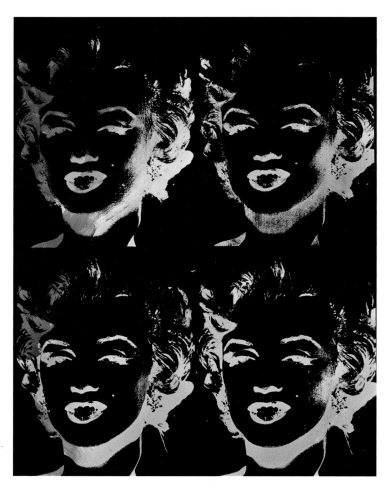

FIGURE 56: **FOUR MULTICOLORED MARILYNS ("REVERSAL" SERIES)**, 1979–86. Synthetic polymer paint and silkscreen ink on canvas, 36 x 28" (91.4 x 71.1 cm). Collection of Jane Holzer, New York

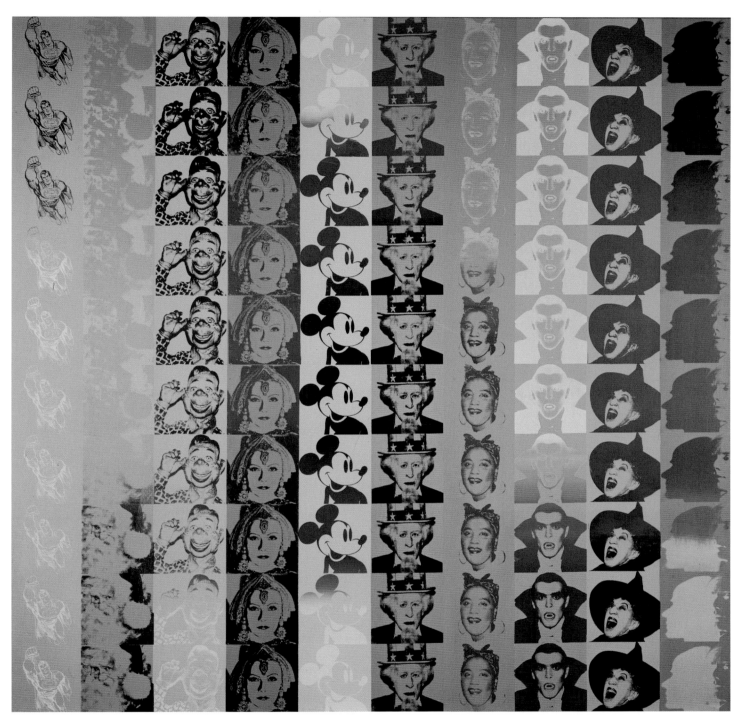

FIGURE 57: **MYTHS**, 1981. Synthetic polymer paint and silkscreen ink on canvas, 100 x 100" (254 x 254 cm). Courtesy O'Hara Gallery, New York

SYMBOLISM

" **…just look at the surface of my paintings and films and me, and there I am. There's nothing behind it."**

—quoted by Gretchen Berg, "Nothing to Lose," 40

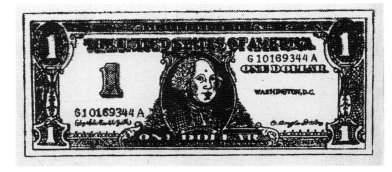

FIGURE 58: **PRINTED DOLLAR #3**, 1962. Silkscreen on canvas, 6 x 10" (15.2 x 25.4 cm). Private Collection

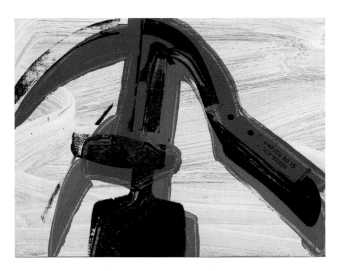

FIGURE 59: **STILL-LIFE (HAMMER AND SICKLE)**, 1976–77. Synthetic polymer paint and silkscreen ink on canvas, 15 x 19" (38.1 x 48.3 cm). The Andy Warhol Museum, Pittsburgh. Founding Collection, Contribution The Andy Warhol Foundation for the Visual Arts, Inc.

FIGURE 60: **EMPIRE**, 1964. 16 mm film still. The Andy Warhol Museum, Pittsburgh. Founding Collection, Contribution The Andy Warhol Foundation for the Visual Arts, Inc.

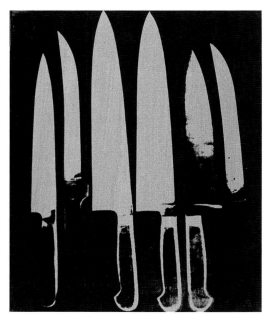

FIGURE 61: **KNIVES**, 1981. Synthetic polymer paint and silkscreen ink on canvas, 20 x 16" (50.8 x 40.6 cm). The Andy Warhol Museum, Pittsburgh. Founding Collection, Contribution The Andy Warhol Foundation for the Visual Arts, Inc.

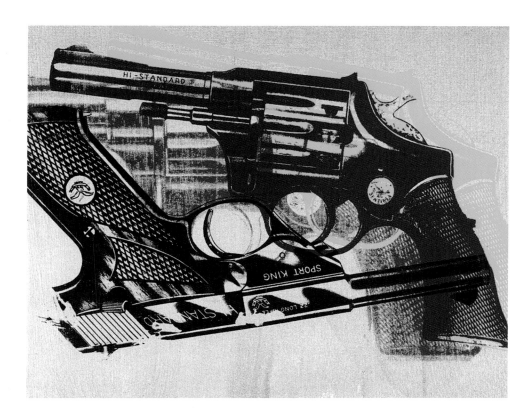

FIGURE 62: **GUNS**, 1981. Synthetic polymer paint and silkscreen ink on canvas, 16 x 20" (40.6 x 50.8 cm). The Andy Warhol Museum, Pittsburgh. Founding Collection, Contribution The Andy Warhol Foundation for the Visual Arts, Inc.

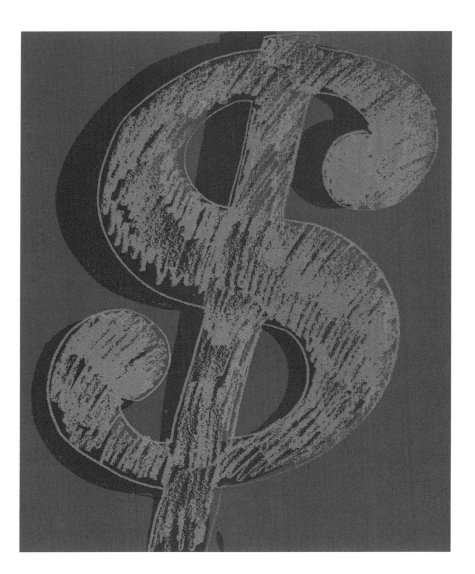

FIGURE 63: **DOLLAR SIGN**, 1981. Synthetic polymer paint and silkscreen ink on canvas, 20 x 16" (50.8 x 40.6 cm). The Andy Warhol Museum, Pittsburgh. Founding Collection, Contribution The Andy Warhol Foundation for the Visual Arts, Inc.

Exhibition Checklist

ALL WORKS BY ANDY
WARHOL (1928–1987)

DISGUISE

SELF-PORTRAIT, 1964
Synthetic polymer paint and
silkscreen ink on canvas
20 x 16" (50.8 x 40.6 cm)
Courtesy The Brant Foundation,
Greenwich, Conn.

**SELF-PORTRAIT
("RETROSPECTIVE" SERIES),**
1979
Synthetic polymer paint and
silkscreen ink on canvas
20 x 16" (50.8 x 40.6 cm)
Private Collection

CAMOUFLAGE, 1986
Synthetic polymer paint and
silkscreen ink on canvas
80 x 80" (203.3 x 203.2 cm)
Courtesy Gagosian Gallery,
New York

SELF-PORTRAIT, 1986
Synthetic polymer paint and
silkscreen ink on canvas
82 x 82" (208.3 x 208.3 cm)
Philadelphia Museum of Art.
Acquired with funds contributed
by the Committee on Twentieth
Century Art and as a partial gift
of The Andy Warhol Foundation
for the Visual Arts, Inc.

DEATH AND DISASTER

5 DEATHS IN ORANGE, 1963
Synthetic polymer paint and
silkscreen ink on canvas
30 3/16 x 30 3/16" (76.7 x 76.7 cm)
Sonnabend Collection

5 DEATHS IN TURQUOISE,
1963
Synthetic polymer paint and
silkscreen ink on canvas
30 1/16 x 30" (76.4 x 76.2 cm)
Sonnabend Collection

5 DEATHS IN YELLOW, 1963
Synthetic polymer paint and
silkscreen ink on canvas
30 1/8 x 30 1/8" (76.5 x 76.5 cm)
Sonnabend Collection

**MOST WANTED MEN NO. 1,
JOHN M.**, 1964
Synthetic polymer paint and
silkscreen ink on canvas
Two canvases, each 49 x 37 3/4"
(124.5 x 95.9 cm)
The Herbert F. Johnson Museum
of Art, Cornell University
Purchase Funds from the
National Endowment for the
Arts and individual donors

RACE RIOT, 1964
Synthetic polymer paint and
silkscreen ink on canvas
30 x 32 7/8" (76.2 x 83.5 cm)
Museum of Art, Rhode Island
School of Design, Providence
Albert Pilavin Memorial
Collection of Twentieth Century
American Art

SIXTEEN JACKIES, 1964
Synthetic polymer paint
and silkscreen ink on 16
joined canvases, 80 x 64"
(203.2 x 162.6 cm)
Collection of David and
Gerry Pincus, Philadelphia

LITTLE ELECTRIC CHAIR, 1965
Synthetic polymer paint and
silkscreen ink on canvas
22 x 28" (55.9 x 71.1 cm)
Courtesy The Brant Foundation,
Greenwich, Conn.

**DISASTER ("RETROSPECTIVE"
SERIES)**, ca. 1978
Unique screenprint on
Saunders paper
30 1/2 x 43" (77.5 x 109.2 cm)
Private Collection

POLITICS

UNTITLED (HUEY LONG),
1948–49
Pen and ink on paper
29 1/16 x 23 1/16" (73.8 x 58.6 cm)
Carnegie Museum of Art,
Pittsburgh. Gift of Russel G.
Twiggs, 1968

**FIGURES HOLDING PICKET
SIGNS**, 1950s
Ink on Strathmore paper
13 1/4 x 11 3/8" (33.7 x 28.9 cm)
The Andy Warhol Museum,
Pittsburgh. Founding Collection,
Contribution The Andy Warhol
Foundation for the Visual Arts, Inc.

FLASH—NOVEMBER 22, 1963,
1968
Portfolio of 11 color screenprints,
1 colophon print of Teletype text,
all on paper, and portfolio cover
Twelve sheets, each 21 x 21"
(53.3 x 53.3 cm)
National Portrait Gallery,
Smithsonian Institution,
Washington, D.C.

MAO, 1972
Screenprint on Beckett High
White paper
36 x 36" (91.4 x 91.4 cm)
Pennsylvania Academy of the
Fine Arts. Gift of Marian Locks,
1975.18

VOTE MCGOVERN, 1972
16-color silkscreen on
Arches 88 paper
42 x 42" (106.7 x 106.7 cm)
National Gallery of Art,
Washington. Gift of Benjamin
B. Smith, 1985.47.229

MAO, 1973
Published for the portfolio
*The New York Collection for
Stockholm*, edition 27/300,
Xerox print on typewriter paper
11 x 8 1/2" (27.9 x 21.6 cm)
Brooklyn Museum of Art. Gift of
Theodore Kheel, 76.201.29

MAO, 1973
Published for the portfolio
*The New York Collection for
Stockholm*, edition 100/300,
Xerox print on typewriter paper
11 x 8 1/2" (27.9 x 21.6 cm)
Brooklyn Museum of Art. Gift of
Theodore Kheel, 76.202.29

MAO, 1973
Published for the portfolio
*The New York Collection for
Stockholm*, edition 265/300,
Xerox print on typewriter paper
11 x 8 1/2" (27.9 x 21.6 cm)
Philadelphia Museum of Art. Gift
of Robert Rauschenberg, Inc.

**THE AMERICAN INDIAN
(RUSSELL MEANS)**, 1976
Synthetic polymer paint and
silkscreen ink on canvas
50 x 42" (127 x 106.7 cm)
The Andy Warhol Museum,
Pittsburgh. Founding Collection,
Contribution The Andy Warhol
Foundation for the Visual Arts, Inc.

**THE AMERICAN INDIAN
(RUSSELL MEANS)**, 1976
Polaroid photograph
4 1/4 x 3 3/8" (10.8 x 8.6 cm)
The Andy Warhol Foundation for
the Visual Arts, Inc., New York

**THE AMERICAN INDIAN
(RUSSELL MEANS)**, 1976
Polaroid photograph
4 1/4 x 3 3/8" (10.8 x 8.6 cm)
The Andy Warhol Foundation for
the Visual Arts, Inc., New York

**THE AMERICAN INDIAN
(RUSSELL MEANS)**, 1976
Graphite on paper
40 x 27" (101.6 x 68.6 cm)
Collection of Jane Holzer,
New York

(FARAH) DIBAH PAHLAVI,
ca. 1978
Unique screenprint on Curtis
rag paper
45 x 35" (114.3 x 88.9 cm)

The Andy Warhol Museum,
Pittsburgh. Founding Collection,
Contribution The Andy Warhol
Foundation for the Visual Arts, Inc.

(FARAH) DIBAH PAHLAVI,
ca. 1978
Polaroid photograph
4 1/4 x 3 3/8" (10.8 x 8.6 cm)
The Andy Warhol Foundation for
the Visual Arts, Inc., New York

(FARAH) DIBAH PAHLAVI,
ca. 1978
Polaroid photograph
4 1/4 x 3 3/8" (10.8 x 8.6 cm)
The Andy Warhol Foundation for
the Visual Arts, Inc., New York

**MAO ("RETROSPECTIVE"
SERIES)**, ca. 1978
Screenprint on Saunders
Waterford (hot pressed) paper
20 7/8 x 15 1/4" (53 x 38.8 cm)
The Andy Warhol Foundation for
the Visual Arts, Inc., New York

SHAH OF IRAN, ca. 1978
Unique screenprint on
Curtis rag paper
45 x 35" (114.3 x 88.9 cm)
The Andy Warhol Museum,
Pittsburgh. Founding Collection,
Contribution The Andy Warhol
Foundation for the Visual Arts, Inc.

**UNTITLED (MAP OF IRAN AND
SURROUNDING COUNTRIES),**
ca. 1984–85
Synthetic polymer paint on
HMP paper
23 5/8 x 31 1/2" (60 x 80 cm)
The Andy Warhol Foundation for
the Visual Arts, Inc., New York

**MAP OF EASTERN U.S.S.R.
MISSILE BASES**, ca. 1985–86
Synthetic polymer paint and
silkscreen ink on canvas
72 x 80" (182.9 x 203.2 cm)
The Andy Warhol Foundation for
the Visual Arts, Inc., New York

LENIN, 1986
Synthetic polymer paint and
silkscreen ink on canvas
Two canvases, each 22 x 16"
(55.9 x 40.6 cm)
Courtesy Gagosian Gallery,
New York

COVER STORIES

DAILY NEWS, ca. 1967
Screenprint on paper
49 7/8 x 29 7/8" (126.7 x 75.9 cm)
Courtesy Gagosian Gallery,
New York

ADIEU ROMY, 1976–86
Four stitched silver gelatin prints
27 1/2 x 21 1/2" (69.9 x 54.6 cm)

The Andy Warhol Museum, Pittsburgh. Founding Collection, Contribution The Andy Warhol Foundation for the Visual Arts, Inc.

ABSTRACT SCULPTURE, 1983
Screenprint on crumpled Mylar
18 x 12 x 9 3/4"
(45.7 x 30.5 x 24.8 cm)
Collection of Christopher Makos, New York

NEW YORK POST FRONT PAGE (GRIM MARINE TOLL), ca. 1983
Synthetic polymer paint and silkscreen ink on canvas
24 x 20" (61 x 50.8 cm)
The Andy Warhol Foundation for the Visual Arts, Inc., New York

NEW YORK POST FRONT PAGE (172—COULD TOP 200), ca. 1983
Synthetic polymer paint and silkscreen ink on canvas
24 x 20" (61 x 50.8 cm)
The Andy Warhol Foundation for the Visual Arts, Inc., New York

NEW YORK POST FRONT PAGE (SAVITCH/MARINE), ca. 1983
Synthetic polymer paint and silkscreen ink on canvas
24 x 20" (61 x 50.8 cm)
The Andy Warhol Foundation for the Visual Arts, Inc., New York

ABSTRACT SCULPTURE, ca. 1984
Synthetic polymer paint and silkscreen ink on canvas
16 x 20" (40.6 x 50.8 cm)
The Andy Warhol Foundation for the Visual Arts, Inc., New York

ABSTRACT SCULPTURE, ca. 1984
Synthetic polymer paint and silkscreen ink on canvas
16 x 20" (40.6 x 50.8 cm)
The Andy Warhol Foundation for the Visual Arts, Inc., New York

ABSTRACT SCULPTURE, ca. 1984
Synthetic polymer paint and silkscreen ink on canvas
16 x 20" (40.6 x 50.8 cm)
The Andy Warhol Foundation for the Visual Arts, Inc., New York

ABSTRACT SCULPTURE, ca. 1984
Synthetic polymer paint and silkscreen ink on canvas
16 x 20" (40.6 x 50.8 cm)
The Andy Warhol Foundation for the Visual Arts, Inc., New York

NEW YORK POST (MADONNA: I'M NOT ASHAMED!), 1985
Screenprint on Lenox Museum Board
40 x 19 7/8" (101.6 x 50.5 cm)

The Andy Warhol Museum, Pittsburgh. Founding Collection, Contribution The Andy Warhol Foundation for the Visual Arts, Inc.

NEW YORK POST (MADONNA ON NUDE PIX: SO WHAT!), 1985
Screenprint on Lenox Museum Board
40 x 19 7/8" (101.6 x 50.5 cm)
The Andy Warhol Museum, Pittsburgh. Founding Collection, Contribution The Andy Warhol Foundation for the Visual Arts, Inc.

ADVERTISING

BEFORE AND AFTER, 1961
Synthetic polymer paint on canvas
54 x 69 7/8" (137.2 x 177.5 cm)
The Museum of Modern Art, New York. Gift of David Geffen, 1995

COOKING POT, 1962
Photoengraving on Rives BFK paper
10 x 7 1/2" (25.4 x 19 cm)
Philadelphia Museum of Art Purchased with the Print Revolving Fund

APPLE, 1985
Synthetic polymer paint and silkscreen ink on canvas
22 x 22" (55.9 x 55.9 cm)
The Andy Warhol Museum, Pittsburgh. Founding Collection, Contribution The Andy Warhol Foundation for the Visual Arts, Inc.

BLACKGLAMA (JUDY GARLAND), 1985
Synthetic polymer paint and silkscreen ink on canvas
22 x 22" (55.9 x 55.9 cm)
The Andy Warhol Museum, Pittsburgh. Founding Collection, Contribution The Andy Warhol Foundation for the Visual Arts, Inc.

CHANEL, 1985
Synthetic polymer paint and silkscreen ink on canvas
22 x 22" (55.9 x 55.9 cm)
The Andy Warhol Museum, Pittsburgh. Founding Collection, Contribution The Andy Warhol Foundation for the Visual Arts, Inc.

LIFE SAVERS, 1985
Synthetic polymer paint and silkscreen ink on canvas
22 x 22" (55.9 x 55.9 cm)
The Andy Warhol Museum, Pittsburgh. Founding Collection, Contribution The Andy Warhol Foundation for the Visual Arts, Inc.

MOBIL, 1985
Synthetic polymer paint and silkscreen ink on canvas
22 x 22" (55.9 x 55.9 cm)

Courtesy Ronald Feldman Fine Arts, New York

THE NEW SPIRIT (DONALD DUCK), 1985
Synthetic polymer paint and silkscreen ink on canvas
22 x 22" (55.9 x 55.9 cm)
The Andy Warhol Museum, Pittsburgh. Founding Collection, Contribution The Andy Warhol Foundation for the Visual Arts, Inc.

PARAMOUNT, 1985
Synthetic polymer paint and silkscreen ink on canvas
22 x 22" (55.9 x 55.9 cm)
The Andy Warhol Museum, Pittsburgh. Founding Collection, Contribution The Andy Warhol Foundation for the Visual Arts, Inc.

REBEL WITHOUT A CAUSE (JAMES DEAN), 1985
Synthetic polymer paint and silkscreen ink on canvas
22 x 22" (55.9 x 55.9 cm)
The Andy Warhol Museum, Pittsburgh. Founding Collection, Contribution The Andy Warhol Foundation for the Visual Arts, Inc.

VAN HEUSEN (RONALD REAGAN), 1985
Synthetic polymer paint and silkscreen ink on canvas
22 x 22" (55.9 x 55.9 cm)
The Andy Warhol Museum, Pittsburgh. Founding Collection, Contribution The Andy Warhol Foundation for the Visual Arts, Inc.

TOTAL, ca. 1985
Synthetic polymer paint on HMP paper
31 1/2 x 23 5/8" (80 x 60 cm)
Private Collection

CELEBRITY

BLUE MARILYN, 1962
Synthetic polymer paint and silkscreen ink on canvas
20 x 16" (50.5 x 40.3 cm)
The Art Museum, Princeton University. Gift of Alfred H. Barr, Jr., Class of 1922, and Mrs. Barr

TROY DONAHUE SIX TIMES, 1962
Synthetic polymer paint and silkscreen ink on canvas
36 1/2 x 26 3/4" (92.7 x 67 cm)
Collection of Jane Holzer, New York

SINGLE ELVIS, 1963
Synthetic polymer paint and silkscreen ink on canvas
82 x 40" (208.3 x 101.6 cm)
Akron Art Museum. Purchased with the aid of funds from the National Endowment for the Arts and the L. L. Bottsford Estate Fund

MUHAMMAD ALI, ca. 1977
Polaroid photograph
4 1/4 x 3 3/8" (10.8 x 8.6 cm)
The Andy Warhol Foundation for the Visual Arts, Inc., New York

MUHAMMAD ALI, ca. 1977
Polaroid photograph
4 1/4 x 3 3/8" (10.8 x 8.6 cm)
The Andy Warhol Foundation for the Visual Arts, Inc., New York

O.J. SIMPSON ("SUITE OF ATHLETES" SERIES), 1977
Synthetic polymer paint and silkscreen ink on canvas
40 x 40" (101.6 x 101.6 cm)
The Art Gallery, University of Maryland, College Park, 1982.01.007

O.J. SIMPSON, ca. 1977
Polaroid photograph
4 1/4 x 3 3/8" (10.8 x 8.6 cm)
The Andy Warhol Foundation for the Visual Arts, Inc., New York

O.J. SIMPSON, ca. 1977
Polaroid photograph
4 1/4 x 3 3/8" (10.8 x 8.6 cm)
The Andy Warhol Foundation for the Visual Arts, Inc., New York

MUHAMMAD ALI, 1978
Graphite on HMP Paper
31 1/4 x 23 3/4" (79.4 x 60.3 cm)
Courtesy The Brant Foundation, Greenwich, Conn.

FOUR MULTICOLORED MARILYNS ("REVERSAL" SERIES), 1979–86
Synthetic polymer paint and silkscreen ink on canvas
36 x 28" (91.4 x 71.1 cm)
Collection of Jane Holzer, New York

MYTHS, 1981
Synthetic polymer paint and silkscreen ink on canvas
100 x 100" (254 x 254 cm)
Courtesy O'Hara Gallery, New York

BONNIE WINTERSTEEN, 1981
Synthetic polymer paint and silkscreen ink on canvas
Two canvases, each 40 x 40" (101.6 x 101.6 cm)
Collection of Laura McIlhenny Wintersteen

SYMBOLISM

DOLLAR BILL, 1962
Silkscreen on canvas
20 x 16" (50.8 x 40.6 cm)
Private Collection

PRINTED DOLLAR #3, 1962
Silkscreen on canvas
6 x 10" (15.2 x 25.4 cm)
Private Collection

EMPIRE, 1964
16 mm film, black and
white, silent
8 hours, 5 minutes at 16 fps
The Andy Warhol Museum,
Pittsburgh. Founding Collection,
Contribution The Andy Warhol
Foundation for the Visual Arts, Inc.

**STILL-LIFE (HAMMER AND
SICKLE)**, 1976
Synthetic polymer paint and
silkscreen ink on canvas
72 x 86" (182.9 x 218.4 cm)
Courtesy Leo Castelli Gallery

**STILL-LIFE (HAMMER AND
SICKLE)**, 1976–77
Synthetic polymer paint and
silkscreen ink on canvas
15 x 19" (38.1 x 48.3 cm)
The Andy Warhol Museum,
Pittsburgh. Founding Collection,
Contribution The Andy Warhol
Foundation for the Visual Arts, Inc.

**STILL-LIFE (HAMMER AND
SICKLE)**, 1976–77
Synthetic polymer paint and
silkscreen ink on canvas
15 x 19" (38.1 x 48.3 cm)
The Andy Warhol Museum,
Pittsburgh. Founding Collection,
Contribution The Andy Warhol
Foundation for the Visual Arts, Inc.

**STILL-LIFE (HAMMER AND
SICKLE)**, 1976–77
Synthetic polymer paint and
silkscreen ink on canvas
15 x 19" (38.1 x 48.3 cm)
The Andy Warhol Museum,
Pittsburgh. Founding Collection,
Contribution The Andy Warhol
Foundation for the Visual Arts, Inc.

**STILL-LIFE (HAMMER AND
SICKLE)**, 1976–77
Synthetic polymer paint and
silkscreen ink on canvas
19 x 15" (48.3 x 38.1 cm)
The Andy Warhol Museum,
Pittsburgh. Founding Collection,
Contribution The Andy Warhol
Foundation for the Visual Arts, Inc.

DOLLAR SIGN, 1981
Synthetic polymer paint and
silkscreen ink on canvas
20 x 16" (50.8 x 40.6 cm)
The Andy Warhol Museum,
Pittsburgh. Founding Collection,
Contribution The Andy Warhol
Foundation for the Visual Arts, Inc.

DOLLAR SIGN, 1981
Synthetic polymer paint and
silkscreen ink on canvas
20 x 16" (50.8 x 40.6 cm)
The Andy Warhol Museum,
Pittsburgh. Founding Collection,
Contribution The Andy Warhol
Foundation for the Visual Arts, Inc.

DOLLAR SIGN, 1981
Synthetic polymer paint and
silkscreen ink on canvas
20 x 16" (50.8 x 40.6 cm)
The Andy Warhol Museum,
Pittsburgh. Founding Collection,
Contribution The Andy Warhol
Foundation for the Visual Arts, Inc.

DOLLAR SIGN, 1981
Synthetic polymer paint and
silkscreen ink on canvas
20 x 16" (50.8 x 40.6 cm)
The Andy Warhol Museum,
Pittsburgh. Founding Collection,
Contribution The Andy Warhol
Foundation for the Visual Arts, Inc.

GUNS, 1981
Synthetic polymer paint and
silkscreen ink on canvas
16 x 20" (40.6 x 50.8 cm)
The Andy Warhol Museum,
Pittsburgh. Founding Collection,
Contribution The Andy Warhol
Foundation for the Visual Arts, Inc.

GUNS, 1981
Synthetic polymer paint and
silkscreen ink on canvas
16 x 20" (40.6 x 50.8 cm)
The Andy Warhol Museum,
Pittsburgh. Founding Collection,
Contribution The Andy Warhol
Foundation for the Visual Arts, Inc.

GUNS, 1981
Synthetic polymer paint and
silkscreen ink on canvas
16 x 20" (40.6 x 50.8 cm)
The Andy Warhol Museum,
Pittsburgh. Founding Collection,
Contribution The Andy Warhol
Foundation for the Visual Arts, Inc.

GUNS, 1981
Synthetic polymer paint and
silkscreen ink on canvas
16 x 20" (40.6 x 50.8 cm)
The Andy Warhol Museum,
Pittsburgh. Founding Collection,
Contribution The Andy Warhol
Foundation for the Visual Arts, Inc.

KNIVES, 1981
Synthetic polymer paint and
silkscreen ink on canvas
20 x 16" (50.8 x 40.6 cm)
The Andy Warhol Museum,
Pittsburgh. Founding Collection,
Contribution The Andy Warhol
Foundation for the Visual Arts, Inc.

KNIVES, 1981
Synthetic polymer paint and
silkscreen ink on canvas
20 x 16" (50.8 x 40.6 cm)
The Andy Warhol Museum,
Pittsburgh. Founding Collection,
Contribution The Andy Warhol
Foundation for the Visual Arts, Inc.

BOOKS

EXPOSURES, 1979
Printed book 9 1/2 x 11 1/2"
New York: Andy Warhol Books
and Grosset & Dunlap
The Archives of The Andy Warhol
Museum, Pittsburgh. Founding
Collection, Contribution The
Andy Warhol Foundation for the
Visual Arts, Inc.

AMERICA, 1985
Printed Book 11 5/16 x 8 7/8"
New York: Harper & Row
Private Collection

ARCHIVAL MATERIAL, MAGAZINES, AND ASSORTED OBJECTS

All objects courtesy The Archives
of The Andy Warhol Museum,
Pittsburgh. Founding Collection,
Contribution The Andy Warhol
Foundation for the Visual Arts, Inc.

Interview magazine covers and stories

Anne Holbrook and
Beverly Johnson, "Should Nixon
be Impeached? Celebrities
Answer," September 1973;
Politics Issue: Jerry Brown, "Jerry
Brown," "Spiro Angnew," and
"Maria Vittoria Mussolini,"
July 1976;
Margaret Trudeau, "Farah
Pahlavi," March 1978;
Nancy Reagan,
December 1981 (cover only);
John McEnroe, "Shirley Temple
Black: Ambassador," August 1982;
Chris Atkins, "Ferdinand Marcos,"
May 1983;
L.A. Olympics, January/February
1984 (cover only);
Mel Gibson cover,
"Mme. Mitterand," June 1984;
Joan Rivers, December 1984
(cover only);
Prince Albert of Monaco,
January 1986 (cover only)

Magazines with covers designed by Warhol

The Fonda Family, *Time*,
16 February 1970;
Jimmy Carter, *New Republic*,
22 January 1977;
Michael Jackson, *Time*,
19 March 1984;
Lee Iacocca, *Time*, 1 April 1985;
Mario Cuomo, *Manhattan inc.*,
September 1985;
Ted Turner, *Madison Avenue*,
June 1986;
John Gotti, *Time*,
19 September 1986

Source material for works of art

Disaster: "Electric Chair,"
"5 Deaths," "Green Disaster,"
"Race Riot," "Thirteen Most
Wanted Men," and "Jackie"
Politics: "Mao," selections from
Warhol Scrapbook, vol. 12, large
Advertising: "Before and After,"
"Cooking Pot," and "Total"
Cover Stories: "Daily News"
(flower silhouettes)
Celebrity: "Liz," "Marilyn," "Elvis"
Symbolism: "Guns,"
Butcher Knives

TIME CAPSULE #232
containing actual *New York Daily
News* and *New York Post* cover
stories from December 1978 to
February 1980

PHOTOGRAPH CREDITS

ART RESOURCE, NEW YORK:
figs. 10, 29, 37, 43–46, 48, 53
RICARDO BLANC: fig. 40
RICK ECHELMEYER: figs. 3, 14–18,
26, 39, 42
RICHMAN HAIRE: fig. 54
ROBERT HÄUSSER: fig. 7
ROBERT McKEEVER: figs. 20, 30, 41
ROBERT RUSCHAK: figs. 1, 2, 5
RICHARD STONER: figs. 9, 32, 38,
49, 59, 61–63
GRAYDON WOOD: figs. 11, 21, 35, 47